Victoria and Albert Museu

D0940701

**100 things to see
in the
Victoria & Albert Museum**

London: Her Majesty's Stationery Office

© Crown copyright 1984
First published 1962
Second edition 1984

Design by HMSO Graphic Design

Printed in the UK for HMSO
Dd 718111 C200

ISBN 0 11 290414 9

The following abbreviations have been used throughout:
H. Height
L. Length
W. Width
D. Depth
Diam. Diameter

Foreword

This little book has the modest aim of meeting the needs of the visitor in a hurry. Out of the thousands of objects on display scattered over the many acres of the V & A we have chosen a hundred which present the essence of the place both in terms of content and quality. As a building the museum has always been a maze. That, it is now recognized, is part of its charm, for it is a constant voyage of discovery but it is also a perpetual irritant for those who wish to come to terms with its most important artefacts swiftly. We hope that this alliance of photograph, location guide and map will alleviate a part of the frustration. Apart from that, such a compilation remains a handy *aide-memoire* to evoke the treasures of the V & A.

Sir Roy Strong
Director
Victoria & Albert Museum

HOW TO USE THIS BOOK
1. The objects are arranged in chronological order under departments.
2. Each object has its room number clearly marked. To find out how to find it turn to the map.
3. Objects which have no room number listed or are missing from their given location are either on loan, being conserved or have been moved. Please contact the Press Office where staff will be able to tell you when they will be on display again.

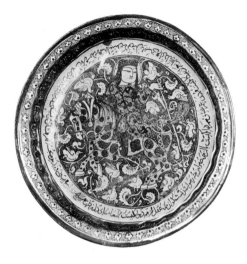

11th and 12th centuries, to Syria and Persia in the 13th, the secret recipe was carried by master-potters seeking new markets and settling in new lands.

This dish, made in the Persian desert town of Kashan (possibly by the potter Abu Zaid) and dated 604 H/AD 1207, represents the period when the technique reached its artistic and technical apogee. The fineness of the moulded shape – derived from metalware – is made possible by the use of an artificial 'quartz frit' body composed chiefly of ground quartz with small additions of white clay and glass frit. This is covered with an opaque white tin-glaze and fired. The lustre pigment – a mixture of compounds of silver and copper with other substances – is painted on to the hard glaze and the piece is refired in a 'muffle kiln', which fixes a silver and copper stain to the surface of the glaze to give the metallic and mother-of-pearl reflections for which the technique is valued.

The style of painting, with its densely-textured surface, was developed in Kashan to show off this technique to its best and is as fine as any manuscript painting of the period. The polo-player belongs to a series of images apparently representing scenes from courtly life.
(No. C.51-1952)

1 DISH WITH POLO-PLAYER
Persian; AD 1207
Diam. 34.9cm (1ft 1¾in)
ROOM 42

The lustre technique of ceramic decoration runs as an unbroken thread through the whole history of medieval Islamic ceramics. From its beginnings in 9th century Mesopotamia, through Egypt in the

2 THE LUCK OF EDENHALL
Gilt and enamelled glass beaker with leather case
Syrian; mid-13th century, the case perhaps French, mid-14th century
H. 15.9cm (6¼in)
ROOM 42

The elaborately gilt and enamelled glass vessels of 13th century Syria are one of the chief glories of the medieval Islamic glass-maker's art. The pieces were first free-blown before the appli-cation of gilding and the firing-on of the many enamel colours. Owing to their fragile nature, few pieces survive whole and, of these, fewer still preserve their original brilliance. This beaker owes its pristine condition to the case of tooled leather (*cuir bouilli*), itself a medieval work of art of great interest.

The glass itself was made,

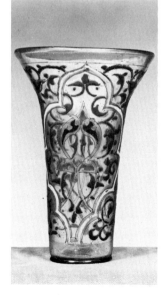

possibly in Aleppo, in the middle of the 13th century, and it found its way to Europe in the hands, no doubt, of a returning pilgrim or crusader. By the mid-14th century its European leather case had been fashioned for it, perhaps in France.

The rarity of the glass and case is further enhanced by the legends that surround it in England, where it had been owned, probably since medieval times, by the Musgrave family of Edenhall in Cumberland, who held that the fortunes of the family depended on its safe keeping. References to the glass and its magical properties are found in 18th century literature, which relate the old tradition that the glass was left near the Well of St Cuthbert near Edenhall by a party of fairies who were disturbed in their merry-making.
(No. C.1-1959)

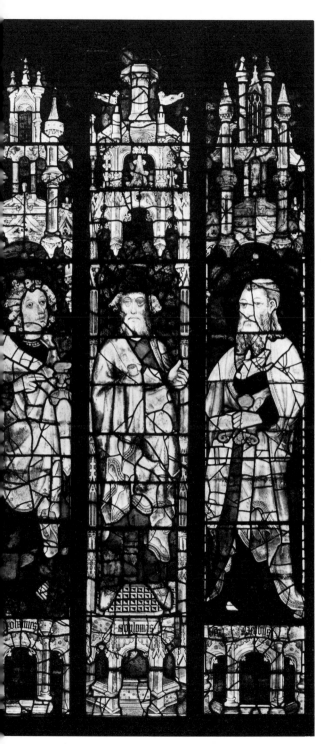

3 STAINED GLASS WINDOW
English; c.1400
H. 3.54m (11ft 7½in)
W. 1.64m (5ft 5in)
ROOM 23

The three lights of this stained glass window show St John the Evangelist, the Prophet Zephaniah and St James the Less. They formed part of the original glazing of the side windows of the chapel of Winchester College in Hampshire, founded by William of Wykeham and built between 1387 and 1394. The glass was painted in the workshop of Master Thomas of Oxford, who also supplied the windows of Wykeham's other foundation, New College, Oxford.

The delicate drawing, the silvery effect of the white glass and the soft, rich colours are typical of the changes taking place in English stained glass of the late 14th century. The figure-painting shows continental, probably German, influence and the architectural settings in which the figures stand, in particular the canopies filling the upper part of the lights, are amongst the most elaborate of their date.

By the early 19th century the Winchester College chapel windows were suffering from severe decay and were taken out for conservation between 1822 and 1828 by the Shrewsbury firm of Betton and Evans. On examination they found there was little they could do to restore them, and so a complete copy was made.
(No. 4237-1855)

4 GOBLET AND COVER
Venetian; late 15th century
H. 45.7cm (1ft 6in)
ROOM 19

The origin of the art of glass-making on the islands of the Venetian lagoon are still obscure, although glass furnaces dating from the 7th century have been excavated at Torcello. However, constant contact through the powerful Venetian mercantile fleet with the glass-making centres of the Middle East, notably

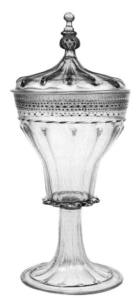

Damascus and Aleppo, ensured the emergence of Venice in the 13th century as the glass-producing centre of the Western World. Ostensibly to reduce the risk of fire in the heart of the Republic, the glass furnaces were moved to the neighbouring island of Murano in 1292, but this had the additional advantage of better preserving the secret of fine glass-making from inquisitive foreigners.

The glass illustrated represents Venetian glass-making at its height. The very size of the goblet itself is a remarkable tribute to the skill of the Venetian glass-blowers,

as is the clarity of the metal. The rim of the bowl is decorated with gilding and enamel, a typical feature of the period. This clear glass, referred to as *cristallo* because of its resemblance to rock-crystal, was made using soda obtained from burnt sea plants known as *barrilla*. The addition of manganese decolour-ized the glass to produce a clear metal which was unrivalled until the discovery by the Englishman, George Ravenscroft, of lead-crystal in the late 17th century. (No. 678-1884)

5 THE LOUIS XII TRIPTYCH
French (Limoges); c.1500
H. 24cm (9½in) W. 41.5cm (1ft 4⅓in)
ROOM 26

This is one of the most important Limoges triptychs in existence. It depicts Louis XII, King of France 1498–1515, the first French monarch to take an active interest in the Italian Renaissance. He married Anne of Brittany in 1499 and the painted arms show the linking of the two Houses. It is not possible to say categorically that the Triptych cele-brates the marriage, but the enamel must date from about that time.

Painted enamelling probably began in France in the 1460s and superseded the *champlevé* technique whereby the colours were applied in cavities formed in the metal ground. With the new technique, the design was sketched on a white enamel base, then painted with the necessary colours. The copper plaque was next quickly fired.

The artist who made the Triptych is not identifiable, although there is a possibility that he may have been one of the Penicaud family of enamellers. It is likely that he based the Annunciation scene on a German woodcut or on a French illuminated manuscript. The sources of the portraits have not so far been identified, though they may well derive from an illumination. Like all enamellers working in this period, this artist successfully introduced Renaissance architectural motifs into scenes (as on this Triptych and the *Nativity* plaque in an adjacent case in this gallery) which are in other respects predominantly Gothic in style and feeling.
(No. 552-1877)

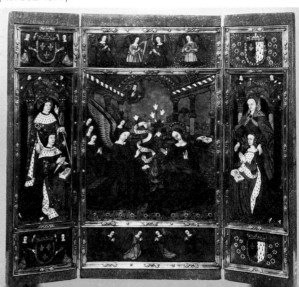

itself a medium worth of that particularly gifted age, the Italian Renaissance.
(No. 1717-1855, Catalogue No. 307)

6 CAFAGGIOLO MAIOLICA DISH
Italian; c.1510
Diam. 23.5cm (9¼in)
ROOM 14

Maiolica, faience, delft: the terms would be interchangeable were it not that they have come to be applied to the pottery of different periods and geographical regions. All three describe a class of pottery with an opaque white tin-glaze that had reached Europe from the Near East.

The present maiolica dish was made at Cafaggiolo, near Florence, and bears the workshop monogram SP crossed by a paraph (a flourish at the end of a signature to make forgery more difficult). It has been suggested that the dish was painted by a certain Jacopo, who inscribed his name on the adjacent dish painted with the furiously cantering Judith. If so, it is probably Jacopo himself who is portrayed, watched at his work by two well-dressed patrons. Notice how he steadies a half-finished maiolica plate on his knee and skilfully paints freehand on to its still unfired white tin-glaze a complicated border pattern. On a stool beside him can be seen six saucers, each with its own brushes and containing one of the brilliant, durable colours that made up his limited palette. At its best, as here, maiolica proved

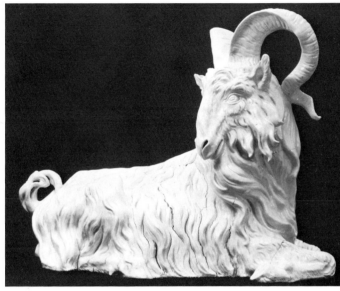

7 MEISSEN PORCELAIN FIGURE OF A GOAT
German; c.1732
L. 66cm (2ft 2in) H. 55cm (1ft 10in) W. 34.5cm (1ft 1½in)
ROOM 142

In 1717 Augustus the Strong, King of Poland and Elector of Saxony, the founder and protector of the Meissen porcelain factory, bought the so-called 'Dutch Palace' in Dresden. This he renamed the 'Japanese Palace', intending to furnish it with porcelain objects of great size. In 1729 the palace was enlarged, and an upper-floor gallery built to house Meissen porcelain, including a series of large-scale animal figures, some life-size. In 1731 a young sculptor, Johann Joachim Kandler, was called in to assist in the work. Kandler, who was to become the virtual inventor of the European style of figure-modelling, was mainly engaged on these projects for the 'Japanese Palace' between 1731 and the King's death in 1733.

The series of large white animal figures never went into production as models for sale to the public and only a few duplicates from the former Electoral collections have found their way into collections outside Dresden. Among these is an example of Kandler's nanny-goat and kid, the pair to the present model, that may be seen at the Ashmolean Museum in Oxford. Tremendous technical difficulties attended the firing of these large figures and many of them, like the Victoria and Albert's goat, show serious fire-cracks. Seldom in later times has porcelain been used for works of sculpture on this ambitious scale.
(No. C.111-1932)

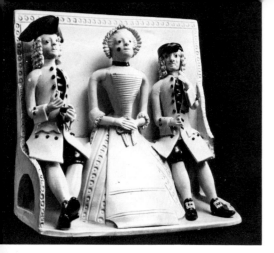

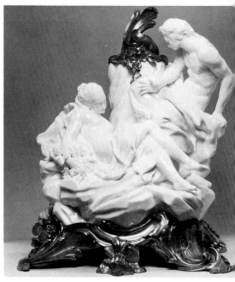

8 PEW GROUP
Salt-glazed stoneware
English (Staffordshire); c.1740
H. 16.3cm (6⅜in) W. 17.5cm (6⅞in)
ROOM 126

The technique of salt-glazing was introduced to Staffordshire some time shortly before 1700, and by the 1720s a white body containing calcinated flint and Dorset pipe-clay had been developed. Allowing moulding or modelling to be crisply reproduced, the thin salt-glaze was soon found suitable for some of the first figures made in Staffordshire. While many of these were formed by moulding or casting, the very rare type known as the Pew Group was always built up by hand from strips of clay, rather in the manner of gingerbread: details were added in contrasting brown clay, sometimes taking the form of twisted white and brown rope-work. Other types of decoration consisted of small impressed designs and incised lines filled with either cobalt or iron oxide, known respectively as 'scratch-blue' and 'scratch-brown' techniques.

Pew groups have long been considered one of the highest achievements of the Staffordshire potter, representing the spontaneous and often humorous creation of the unsophisticated hand. Many of the figures depict rustic musicians and these exhibit, perhaps because of the limitations imposed on the potter by the use of only two colours, a much stronger feeling for characterization than the coloured so-called Astbury figures which were made during the same period. Less than 20 pew groups are known, twelve of which are now in public collections; of the rare class which includes three seated figures, this example must range as one of the best.
(No. C.6-1975)

9 VINCENNES PORCELAIN GROUP
L'Heure du Berger
French; c.1749–52
H. 29.5cm (11⅝in) L. 24.5cm (9½in)
W. 20.5cm (8in)
ROOM 4

The factory at Vincennes, founded in 1745 and transferred to Sevres in 1756, had as its first director the cultivated Monsieur Hulst, whose intention it was to create a French style that would owe nothing to the fashion of the Orient or Germany. Jean-Jacques Bachlier was put in charge of the painting and sculpture studios, and part of his responsibility was to supply the workmen with sources of design.

The most fashionable artist of the day was Francois Boucher, Madame de Pompadour's protege and a prolific draughtsman, painter and designer. Naturally, the factory at Vincennes looked to him as the inspiration for many of its figures, as well as much of the painted decoration. Indeed, Bachlier himself may have introduced Boucher personally to the factory, for the two men had been colleagues at the Academy. *L'Heure du Berger* is taken from *Le Repos de Diane*, engraved by Jean Pelletier after Boucher. It was modelled in soft-paste porcelain by an unknown artist some time between 1749 and 1752 and is mounted in contemporary gilt bronze. The refinement of the modelling makes this group one of the loveliest produced by an 18th century factory, and it epitomizes the French style that Vincennes so wished to create.
(No. C.356-1909)

10 CHELSEA PORCELAIN CHINOISERIE GROUP
English; c.1756
H. 35.6cm (1ft 2in) W. 36cm (1ft 2¼in)
ROOM 123

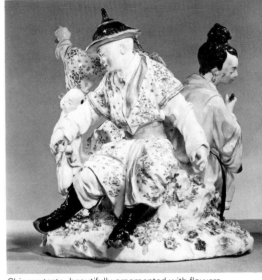

English porcelain arrived relatively late on the European scene, at a time when the porcelain figure had already reached its full development at the hands of Kandler at Meissen and his German contemporaries. Joseph Willems, the Flemish-born sculptor who almost certainly modelled the piece illustrated here, was normally content to follow the style and scale made familiar by Meissen, even when not copying existing Meissen models. The *Chinoiserie* group of musicians (a characteristic European vision of Cathay), which survives in only one other example, is one of the most ambitious and original of his models and has no close European counterpart. The circular composition suggests that it was meant for display in the middle of a table and the presence of a round hole in the centre of its base may indicate that it was once completed by a metal and glass lustre rising from there. It was probably an example of this group that was described in the catalogue of the sale held by the Chelsea factory in 1756 as 'A most magnificent LUSTRE in the Chinese taste, beautifully ornamented with flowers, and a large group of Chinese figures playing on music.'
(No. C.40-1974)

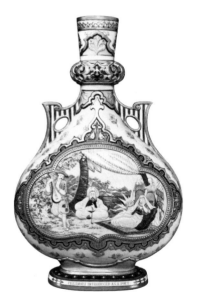

11 PORCELAIN VASE
English (Worcester); 1874
H. 41.3cm (1ft 4¼in)
ROOM 118

The Worcester Royal Porcelain Company is the only English porcelain manufacturer which can boast an unbroken history of production from the 18th century. Porcelain-making began in Worcester at Dr Wall's factory in 1751. This concern was acquired in 1783 by Thomas Flight, who was joined by Martin Barr ten years later. A rival factory belonging to Robert Chamberlain, established in about 1786, combined with Flight, Barr and Barr in 1840. After twelve years the firm was purchased by W.H. Kerr and R.W. Binns and this company was, in turn, incorporated into the Royal Worcester Porcelain Company in 1862. The appointment of R.W. Binns as artistic director of the new enterprise ensured a return to the high standards of earlier Worcester porcelains.

The vase illustrated dates from 1874 and is in a taste generally known at the time as 'Moorish', an interpretation of the arts of Islam and India which fascinated 19th century artists and designers. The scenes on the vase are moulded as well as painted, perhaps in imitation of contemporary Persian tiles, and are inscribed 'FERAMORZ INTRODUCED AS A POET' and 'ZELICA and MOKANNA'. The episodes are taken from 'The Veiled Prophet of Khorassen' in Thomas Moore's *Lalla Rookh*, illustrated by Hablet Knight Brown (Phiz) and G.H. Thomas in the Routledge, London, edition of 1868 (pp 13, 43 and frontispiece).
(No. C.63-1972)

12 SLIPWARE DISH
by Bernard Leach (1887–1979)
English; 1923
Diam. 41.9cm (1ft 4½in)
ROOM 137

The design of this splendid bowl shows the Tree of Life surrounded by a ring of fishes. In Leach's own words, this is 'a subject that relates to a very old tradition and which may be regarded as symbolic.' The tradition to which the bowl belongs is an English one dating back for more than 500 years. The design is painted in an iron-rich clay slip on to the earthenware body and the whole covered with a honey-coloured transparent lead glaze.

The materials and the vigour of potting and painting are both very English, though the design

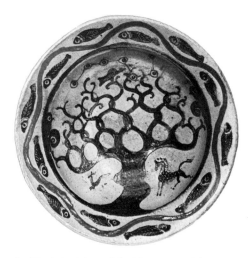

itself harks back to an Oriental prototype. It is one that appears periodically in his work. The bowl was made in 1923 at St Ives, three years after Leach had returned from Japan. He had been introduced to potting in 1911 while in the Far East and had spent the following nine years there learning his craft. His only contact with English pots had been through photographs and on his return to England the discovery and exploration of the rural English potting tradition became one of his first aims. His work in this field is as important as his introduction of Far Eastern styles and techniques.
(No. C.1278-1923)

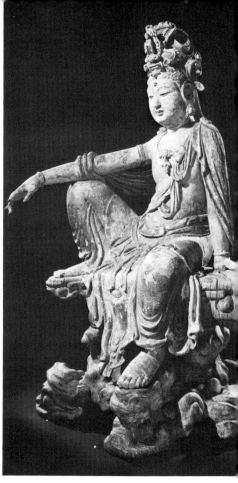

13 PAINTED WOOD SCULPTURE OF THE BODHISATTVA GUANYIN
Chinese; 12th–13th century
H. 1.25m (4ft 1¼in)
ROOM 44

Monumental sculpture in China found its chief inspiration in Buddhism, which was introduced from India during the early centuries of our era. In providing the innumerable images required for shrines and temples, the stone carvers brought their art to an illustrious peak during the 5th–9th centuries, after which the demand was increasingly fulfilled by carvings in wood. This statuary was at first closely based on Indian models which were, however, soon absorbed into a distinctively Chinese idiom. Among the subjects most favoured were the Bodhisattvas, beings who had attained enlightenment but renounced paradise in order to work for the alleviation of men's sufferings, and Guanyin or Guanshiyin – 'he that hears the prayers of the world'

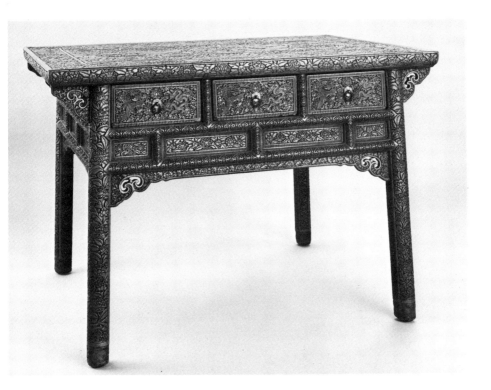

14 CARVED LACQUER TABLE
Chinese; c.1426-35
H. 79.2cm (2ft 7¼in)
L. 1.19m (3ft 11in)
D. 84.5cm (2ft 9¼in)
ROOM 44

This table is a unique survival of the luxurious furniture of the Chinese elite of the early Ming dynasty. It was probably made in the lower Yangtze valley area, where a humid climate gives good conditions for the production of carved lacquerware, in which over 100 layers of the sap of the lacquer tree are successively painted on to a wooden core to give a thickness sufficient for carving. The lacquer is coloured with mercuric sulphide (cinnabar) to give the typical rich vermilion colour. Here, dragons and mythical birds cover the upper surface and drawer fronts, while flowers and foliage decorate the legs and sides. Such a large object may have taken years to complete. It carries the mark of the Xuande period (1426–35) and hence is one of the earliest pieces of Chinese furniture surviving in any form. The unevenness of the upper surface makes it unlikely that it was used as a writing desk, despite its proportions, and it probably stood against a wall in a formal reception room, with the drawers and space below being used for storage.
(No. F.E.6-1973)

– became an object of special reverence. He is shown here in his aspect as the 'Guanyin of the South Seas' and in his original setting would have been seated in a grotto-like niche carved in wood, representing his home on the boulder-strewn shore of Putuoshan island off the coast of Zhejiang province. This sculpture of wood, painted and gilt over gesso, comes from a group which has been identified as representative of a style associated with Shanxi province. Like many wood sculptures of its type, it has undergone several restorations and repaintings during its life, but a recent programme of conservation has exposed the original colouring in many places.
(No. A.7-1935)

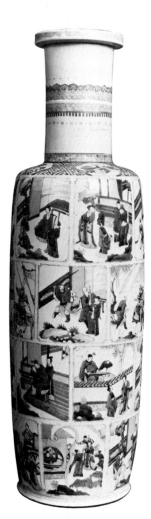

15 BLUE AND WHITE PORCELAIN VASE
Chinese; c.1700
H. 77.5cm (2ft 6½in)
ROOM 145

This imposing example of the underglaze-blue porcelain of the Kangxi period (1662-1722) is decorated with scenes from a drama which can be 'read' like a strip cartoon. The play is *The West Chamber*, written in the 13th century but retaining its place to the present day as China's best-loved romantic tale. It tells of the star-crossed lovers Scholar Zhang and Cui Yingying, who meet by chance in a lonely monastery but are only united after many vicissitudes. Dramatic scenes were a staple of the porcelain painters in the factories of Jingdezhen at this period, though such unashamedly sensual subject matter was frowned on by the governing elite and the imperial court. Illustrated printed editions of the play provided the inspiration, but the scenes were handled with a boldness not available to the graphic artist. This vase, a decorative rather than functional object, is part of the extensive collection of Chinese ceramics bequeathed, along with many other pieces, to the Museum in 1910 by George Salting. The bulk of the collection is on display in Room 145.
Salting Bequest (No. C.859-1910)

16 JADE VASE AND COVER
Chinese; 18th century
H. 25.7cm (10in)
ROOM 44

The position of jade in traditional China was roughly equivalent to that of gold in the West. It was not only valued as a gem in itself (though never a medium of exchange), but was also a metaphor in poetry for all things precious and beautiful. The manufacture of large vessels of jade, such as this one, was greatly expanded after the Qing emperors extended their control over the Central Asian sources of the mineral in the 1750s. The stone was, in theory, an imperial monopoly, but widespread smuggling made it available to all who could afford it. Jade carving workshops existed in the 18th century under the control of the imperial household in Peking and other centres, but their products were sometimes deemed inferior to those of the commercial workshops, particularly those in the city of Suzhou. Early Chinese bronze casting was one source of inspiration for the carvers, but on this decorative vase the design is one of quails and millet heads, a subject also seen on porcelain of the period.
Salting Bequest (No. C.1920-1910)

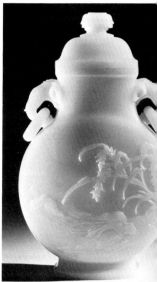

17 SILK SCREEN PANEL (detail)
Chinese; 18th century
H. 2.60m (8ft 6½in)
W. 54.5cm (1ft 9½in)
ROOM 44

This silk screen panel, of which only a detail is shown here, is executed in tapestry weave. *Kesi*, the Chinese name for this weave, has been variously translated as 'carved' or 'split' silk and refers to the vertical spaces occurring between the colour changes in the design. The bobbins carrying the different coloured silks are not taken from selvedge to selvedge but are confined to the areas where the pattern requires that particular colour. Pieces woven in this way are therefore reversible. The flexibility of this technique permits free and flowing designs, such as the twisted willow trunk depicted here. The pool-side scene of stylized rocks, water plants, bamboo and different birds is carried out in a close, neat weave in tones of blue, brown and cream.
(No. T.80-1957)

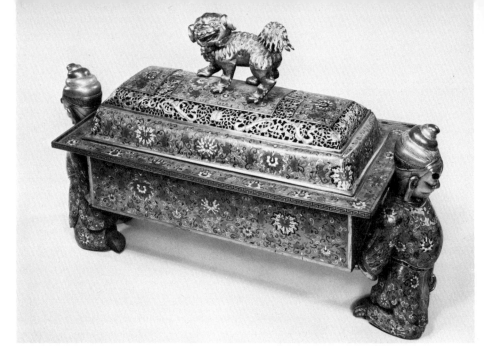

18 ENAMELLED ICE CHEST
Chinese; late 18th-early 19th century
L. 1.10m (3ft 7½in) H. 72cm (2ft 4½in) W. 1.10m (3ft 7½in)
ROOM 44

The harsh heat of a Chinese summer makes a chest for holding blocks of ice, used to cool a room, a necessary piece of furniture. This large and flamboyant example has the chest itself supported by two exotically non-Chinese figures with bulging eyes and curly beards and topped with a snarling lion. The decoration, principally in red, white, yellow and green on a blue ground, is carried out in the *cloisonné* technique of enamelling, where wires soldered to the metal body of the piece serve to divide the colours from each other. The technique reached a first peak in the 15th century when it was confined to small vessels, but it flourished again in the 18th when it was extended to objects of considerable size. The colour scheme and intricate decoration

(which shows signs of having absorbed European influences) are in a taste associated with the imperial court in the latter part of the Qianlong period (1736–95). The chest is one of several pieces in the Museum traditionally said to have come from the complex of imperial summer palaces outside Peking, looted by British and French troops in 1860.
(No. 255-1876)

19 PORCELAIN JAR
Korean; 17th century
H. 34.6cm (1ft 1⅔in)
ROOM 44

The ceramic art of Korea drew many of its technical features and some of its decorative repertoire from China, but modified both in distinctively Korean ways. Painting in colours under the glaze was one such feature, with decoration in underglaze cobalt blue being practised from the 15th century. Difficulties in obtaining cobalt led to the exploration of copper red pigments and, as here, painting in

20 AMIDA NYORAI
Carved wood sculpture, lacquered and gilt
Japanese; 13th century
H. 46.2cm (1ft 6in)
ROOM 47D

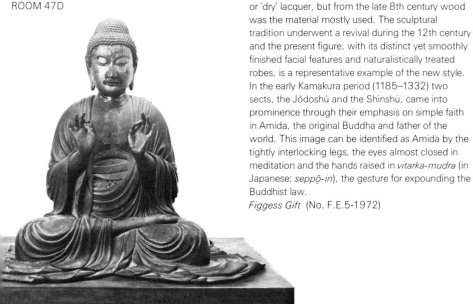

The introduction of Buddhism to Japan during the 6th century AD stimulated a surge of artistic creativity in many fields including sculpture. At first, Buddhist images were chiefly made in bronze, clay or 'dry' lacquer, but from the late 8th century wood was the material mostly used. The sculptural tradition underwent a revival during the 12th century and the present figure, with its distinct yet smoothly finished facial features and naturalistically treated robes, is a representative example of the new style. In the early Kamakura period (1185–1332) two sects, the Jōdoshū and the Shinshū, came into prominence through their emphasis on simple faith in Amida, the original Buddha and father of the world. This image can be identified as Amida by the tightly interlocking legs, the eyes almost closed in meditation and the hands raised in *vitarka-mudra* (in Japanese: *seppō-in*), the gesture for expounding the Buddhist law.
Figgess Gift (No. F.E.5-1972)

a lustrous brown derived from iron. All the elements of the design, from the dragon and clouds to the band of formalized scrolling around the neck of the jar, derive ultimately from Chinese sources, but they are executed with a confident rapidity which is a distinguishing mark of Korean ceramic painting. The precision of finish admired in China seems to have escaped or seemed unnecessary to Korean potters. Jars of this form were used for containing drink at feasts.
(No. C.356-1912)

21 SHINO WARE EWER
Stoneware painted in underglaze brown
Japanese; early 17th century
H. 16.5cm (6½in)
ROOM 44

Shino wares exemplify the changes brought about in Japanese ceramic taste during the Momoyama period (1568–1615) by the development of the tea ceremony, which had previously relied on utensils imported from China. The *wabi* style of tea advocated by the teamaster Sen no Rikyū (1522–91) required vessels that cultivated a deliberate air of simplicity and calm. Painted Shino (*E-Shino*) is a rough stoneware with a thick white glaze applied over designs of an essentially rustic character. The forms include bowls in which tea was

prepared and served, flower vases for the *tokonoma* recess, food dishes, water jars and ewers. Also on display are plain glazed, low-fired *raku* bowls from Kyoto and products of other stoneware kilns. Despite their apparent artlessness, there is a sophistication about these vessels which closely reflects the aesthetic ideals of their teamaster patrons.
(No. C.648-1923)

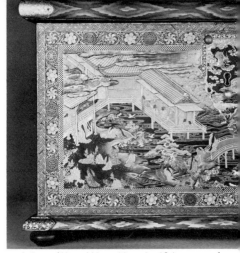

22 THE MAZARIN CHEST
Japanese; c.1640
L. 1.01 m (3ft 4in) W. 64.1cm (2ft 1¼in)
H. 57cm (1ft 10½in)
ROOM 47D

Introduced to Japan from the Asian mainland in the 6th century AD, the technique of decoration by means of metal powders in combination with the sap of the lacquer tree (*Rhus verniciflua*) soon developed into the most characteristic of Japanese crafts. From the late 16th century, trade with the Portuguese and Dutch stimulated the creation of new lacquer styles which, towards the middle of the 17th century, are typified by a black ground decorated in gold and silver. This magnificent wooden chest, decorated in black, gold and silver lacquer, with inlay and overlay of mother-of-pearl, gold, silver and other metals – and the equally fine van Diemen box displayed in an adjoining case – stand out from the mass of export lacquers on account of their very high quality and their extensive figural decoration, based on scenes from the classic novel *The Tale of Genji*, as depicted in contemporary paintings. Stylistic and technical parallels suggest that the chest probably came from the workshop of Kōami Nagashige, the 10th master of the most celebrated official family of lacquerers, with metal details from the workshop of Kenjō, 7th master of the Gotō family. As shown by the arms cast on the European key, the chest belonged to a Mazarin family duke before entering the collection of William Beckford after the French Revolution. (No. 412-1882)

23 KIMONO
Cotton with stencilled decoration
Ryukyuan; late 18th or early 19th century
L. 1.32m (4ft 4in)
ROOM 38A

Kimono patterned with the design of cranes and stylized pine trees were worn as dancing costumes in the Ryukyu islands, a group to the south-west of Japan. The straight-seamed *kimono* lends itself – in Japan as in the Ryukyus – to bold all-over motifs which are achieved by the Ryukyuan polychrome dyeing technique known as *bingata*. The design was gradually built up by a complicated sequence of stencil combinations and applications of rice-paste resist. The dye colour was applied with a brush to those areas of cotton not covered by the resist. Also shown in Room 38A is a changing display of Japanese silk *kimono*. (No. T.18-1963)

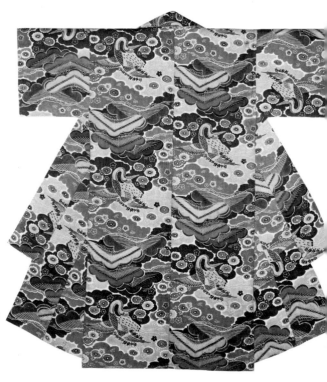

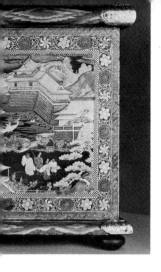

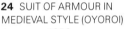

24 SUIT OF ARMOUR IN
MEDIEVAL STYLE (OYOROI)
Japanese; 1859
H. 1.50m (4ft 11in)
ROOM 38A
 This suit of armour is in the
style of the 13th and 14th
centuries and is typical of the
many ostentatious reproductions
of earlier armours which were
made for display rather than use in
the latter part of the Edo period
(1615–1868). The metal parts of
the sleeves, with their pierced
wave and chrysanthemum designs
in gilt bronze, are closely based on
a pair which is still preserved in
Japan and is said to have
belonged to the great hero
Yoshitsune (*d.*1189), although it is
nowadays thought to date from
the mid-13th century. Other
typical features include the low
rounded helmet with its prominent
rivet heads, large rounded neck-
guard and turnbacks covered in
stencilled leather, the large
shoulder-guards, the stencilled
leather panel on the front of the
armour and the four tassets. Less
authentic features are the half-
mask with its long whiskers and
the pendant extensions to the
thigh-guards. The helmet bowl is
signed by a late member of the
Myōchin family, Muneharu, and
dated 1859. The armour was
presented to Queen Victoria by
the last but one *shōgun* (military
ruler) of Japan in 1861 and
donated to the Museum by the
Queen in 1865.
(No. 362-1865)

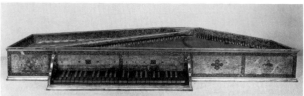

25 SPINET
Venetian; c.1570
H. 17.8cm (7in) W. 1.52m (5ft)
D. 40.6cm (1ft 4in)
ROOM 54

The most historic item in the Museum's collection of musical instruments is this late 16th century Venetian spinet which belonged to Queen Elizabeth I. Its cedarwood case is painted with the Queen's badge of a crowned black falcon holding a sceptre, the Tudor royal coat of arms and gilt arabesque ornament. The keyboard has ebony keys with gilded fronts and accidentals inlaid in *certosina* work with ivory, silver and exotic woods.
(No. 19-1887)

26 THE GREAT BED OF WARE
English; c.1590
H. 2.67m (8ft 9in) L. 3.30m
(10ft 10in) W. 3.23m (10ft 7in)
ROOM 54

This gigantic Elizabethan oak bed – with its carved, painted and inlaid decoration – is perhaps the most famous piece of furniture in the world. It is thought to have been made at the end of the 16th century for the White Hart Inn at Ware in Hertfordshire, which was the first major stopping-place on the journey North from London. The size of the bed earned it instant fame, particularly after it had been referred to by William Shakespeare in his play *Twelfth Night*, which was first performed in 1601. Eight years later Ben Jonson mentioned it in one of his plays and it has been referred to by travellers, historians, playwrights, poets (such as Lord Byron) and antiquarians ever since. It was slept in by Prince Ludwig of Anhalt-Kohten in1596 – and is said to have been occupied by '26 butchers and their wives' on 13th February 1689. A pantomime called *The Great Bed of Ware* was staged in 1837 and a few years later Charles Dickens tried to purchase the bed.
(No. W.47-1931)

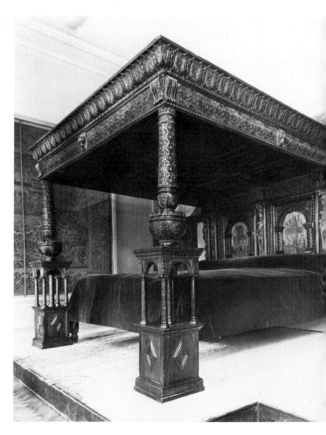

27 PAUL PINDAR HOUSE FRONT
English; early 17th century
H. 7m (23ft) L. 5.49m (18ft)
ROOM 48

This early 17th century oak facade from a house in Bishopsgate Street, London, is one of the principal items in the Museum's architectural court. The two great bay windows comprised the centre of the house, which was built by Sir Paul Pindar (1566–1650), who had made a fortune trading in the Levant and had also served as ambassador to Turkey from 1611–20. The strapwork panels below the windows are carved in contemporary Flemish style and include the arms of the City of London. The facade was presented to the Museum in 1890 by the Great Eastern Railway Company when they were enlarging Liverpool Street Station. Appropriate leaded glass was inserted when the facade was moved to the Museum.
(No. 846-1890)

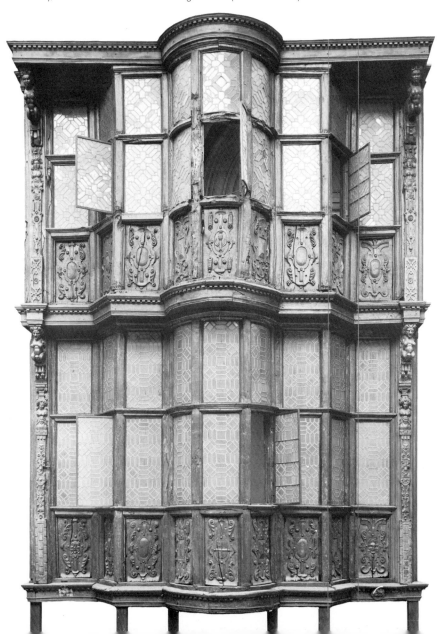

28 CABINET

French; c.1630
H. 1.68m (5ft 6in) W. 1.37m (4ft 6in)
D. 69cm (2ft 3in)
ROOM 1

This ebony cabinet, with gilt bronze reliefs and figures, is thought to have been made for Marie de' Medici (1573–1642), Queen of France, and to have been supplied either for her appartments at the Louvre or the Luxembourg Palace shortly before her exile in 1630.

The front of the cabinet is in the form of a triumphal arch with Corinthian pilasters flanking niches with gilt bronze figures. The embossed gilt bronze reliefs depict scenes of Tancred and Arminta from Torquato Tasso's epic poem *Gerusalemme Liberata*. The design of the cabinet is attributed to Jean Cotelle, and the gilt plaques on the base depict classical sacrificial scenes in the style of Simon Vouet.
(No. W.64-1977)

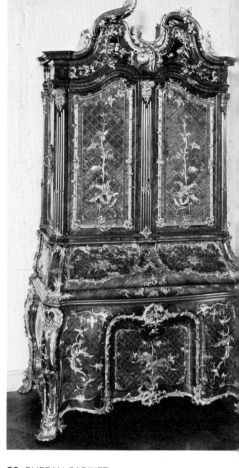

29 BUREAU-CABINET

Dresden; c.1750
H. 2.74m (9ft) W. 1.27m (4ft 2in)
D. 73.7cm (2ft 5in)
ROOM 5

This rococo bureau-cabinet of kingwood with ormolu mounts is inlaid with mother-of-pearl, brass and ivory and decorated with flowers and scrolling foliage. It was made for Augustus III, King of Poland and Elector of Saxony (1696–1763). His AR cypher is carved on a gilt wood cartouche in the interior, which is fitted with drawers and secret compartments. It is one of the most extravagant pieces of furniture produced in the 18th century; its design has been compared to those produced by Johann Michael Hoppenhaupt (1709–55). The bureau-cabinet was acquired by Baron Meyer de Rothschild in 1835 and formed part of the furnishings of Mentmore Towers in Buckinghamshire.
(No. W.63-1977)

30 OVERMANTEL MIRROR FROM THE NORFOLK HOUSE MUSIC ROOM
English; c.1753
H. 2.92m (9ft 7in)
W. 2.16m (7ft 1in)
ROOM 58

The Music Room of the Duke of Norfolk's London house in St James's Square was designed in the early 1750s by the architect Matthew Brettingham Senior, assisted by the Piedmontese architect Giovanni Battista Borra. The overmantel mirror, with its gilt wood frame, corresponds with French *Régence*-style *boiseries* and was carved and gilded by the French craftsman Jean Cuenot. The crest of the mirror is reminiscent of *boiseries* designed by Jean Berain and the musical tropheis are closely related to the engraved designs of Jacques François and Marie Michelle Blondel. The Music Room was completed in 1756 and formed one of a sequence of reception rooms in one of the grandest houses in London at the time. (No. W.70-1938)

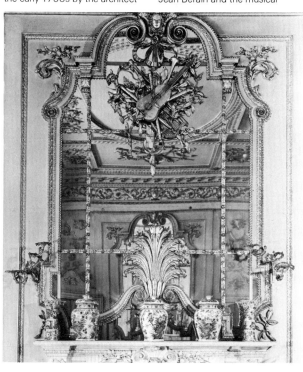

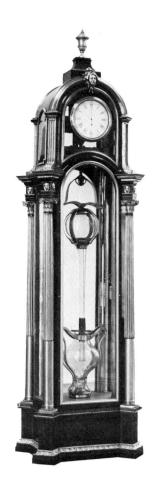

31 THE PERPETUAL MOTION CLOCK
English; c.1760
H. 2.74m (9ft) W. 1m (3ft 5in)
D. 83.8cm (2ft 9in)
ROOM 123

This was the first successful perpetual motion clock produced in England. It was made by James Cox with the assistance of his chief mechanic Joseph Merlin. The movement was driven by mercury, which was held in the glass tubes and bowls in the centre of the glazed case, made of mahogany with ormolu mounts. The clock was one of the principal exhibits in Cox's museum of automata, which was opened at Spring Gardens between 1768 and 1774. In the early 19th century it was displayed at Thomas Weeks' Royal Mechanical Museum in Titchbourne Street, London.
Acquired with the aid of the National Art Collections Fund.
(No. W.20-1961)

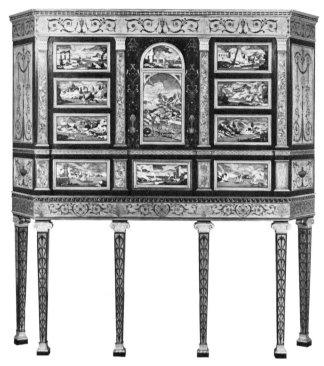

32 THE KIMBOLTON CABINET
English; 1771
H. 1.88m (6ft 2in) W. 1.78m (5ft 10in) D. 33.65cm (1ft 1¼in)
ROOM 122

In 1771 the architect Robert Adam designed a grand cabinet for the display of eleven 'landscaped' plaques which belonged to the Duchess of Manchester. The plaques were made in Florence in the early 18th century by Baccio Capelli. The design was considerably modified when the elaborate neo-classical marquetry cabinet came to be executed. It is considered the masterpiece of Ince & Mayhew, who were a leading firm of cabinet-makers and upholsterers in the second half of the 18th century. The majority of the gilt brass mounts were supplied by Messrs Boulton and Fothergill of Birmingham. The cabinet was completed in 1776 and furnished the state bedroom at Kimbolton Castle, Huntingdonshire.
(No. W.43-1949)

33 WORK-TABLE
French; 1785
H. 76.2cm (2ft 6in)
Diam. 38.1cm (1ft 3in)
ROOM 7

Veneered with tulipwood and decorated with marquetry ormolu and a Severes porcelain plaque, this neo-classical work-table was given by Queen Marie Antionette to Eleanor Eden, following her husband William Eden's successful negotiation of the Treaty of Navigation in 1786. In the same year Louis XVI presented Mrs Eden with a magnificent Sevres dinner service. The floral plaque on top of the table was painted in 1775 by Pierre the Younger and gilded by Vande. The table was made by the *maître-ebéniste* Martin Carlin and completed by Jean-Jacques Pafrat in 1785. Shortly after the table was exhibited at the South Kensington Museum in 1862, it was purchased by John Jones of No. 95 Piccadilly, whose remarkable collection of French 18th century decorative arts was presented to the Museum in 1882.
(No. 1058-1882)

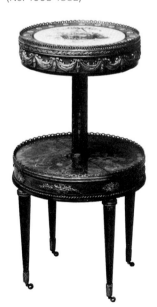

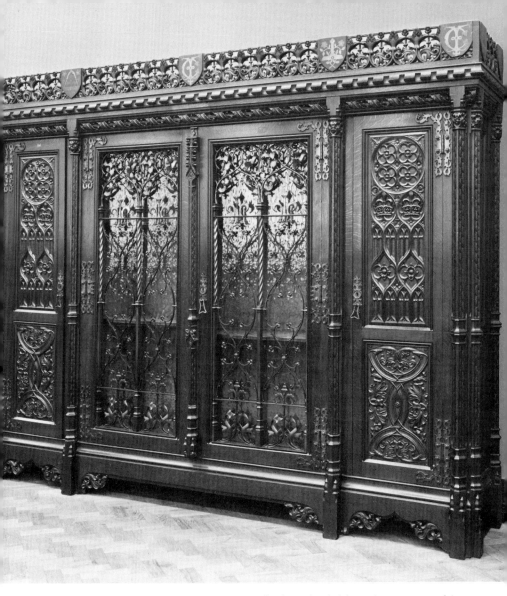

34 BOOKCASE CABINET
English; 1851
H. 2.44m (8ft) L. 3.20m (10ft 6in)
W. 66cm (2ft 2in)
ROOM 120

This bookcase cabinet was the most important piece of Gothic Revival furniture shown at the Great Exhibition of 1851. It was designed by the architect A.W.N. Pugin (1812–52) who had proposed that a section of the exhibition should be devoted to modern works executed in the true spirit of medieval art. Its decoration was influenced by French medieval woodwork. It bears the monogram of the interior decorator John Grace and was commissioned for sale at his showrooms in Wigmore Street, where he hoped to promote the medieval style of decorative arts. The bookcase cabinet was probably made in the workshops of George Myers and the brass ornaments were supplied by Messrs Hardman of Birmingham. It was purchased by the Board of Trade and was the first contemporary piece of furniture acquired by this Museum.
(No. 25-1852)

35 DECORATED WOODEN BOX
Italian; 1881
H. 20.3cm (8in) L. 35.6cm (1ft 2in) D. 20.3cm (8in)

The box, made of wood decorated with painted and gilt gesso, was commissioned from Annibale Mariani of Perugia in 1881, and is an interesting example of Italian 19th century revivalism, based on the *pastiglia* work of the 15th century. It belonged to Lord Leighton of Streeton (1830–96), whose profile portrait appears on the front. He was President of the Royal Academy, and the back of the box bears a reference to his success as an artist — a head of Minerva and a palette with brushes. The box also reflects the interest of English artists and designers in the Italian Renaissance as fostered by South Kensington Museum and School of Art. It now forms part of the Museum's large collection of treen, that is small domestic objects made of wood.
(No. 224-1896)

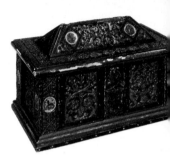

36 SCREEN
by Eileen Gray (1874–1970)
French; c.1922
H. 1.83m (6ft)
W. 1.47m (4ft 10in)

This six-fold screen of black lacquered wooden *briques* was created by the designer/architect Eileen Gray and formed part of the furnishings of her Paris apartment in the rue Bonaparte. The idea for this screen developed from a project for a screen of 450 lacquer *briques* which she had designed around 1920, with the assistance of the lacquerer Inagaki, for the *modiste* Suzanne Talbot's apartment in the rue de Lota. Eileen Gray herself practised the art of lacquering and worked with the Japanese craftsman Sugawara. The screen is a typical example of the individual 'modern' furnishings which were sold at her gallery in the rue du Faubourg St Honoré.
(No. W.21-1972)

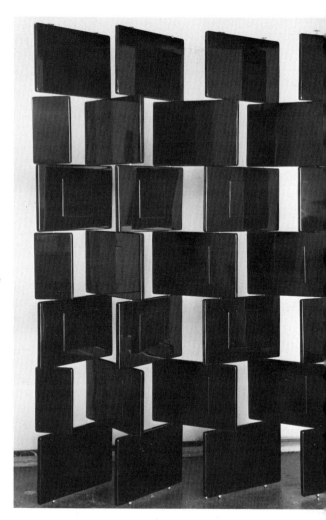

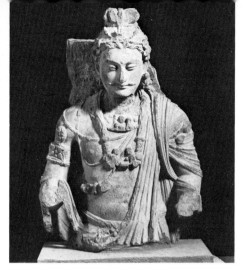

37 GREY SCHIST FIGURE OF THE BODHISATTVA
MAITREYA
Gandhara; 2nd–4th century AD
H. 83cm (2ft 8¾in)
ROOM 47

The area from which this sculpture came, lying in
north-western Pakistan and eastern Afghanistan,
formed the ancient kingdom of Gandhara. Its culture
was deeply influenced by Hellenistic ideas which
had spread from the West partly as a result of
Alexander the Great's campaign which took place
to the south and south-west in 326 BC. Amongst
other things, this stimulated an interest in figure
sculpture and affected the style in which it was
executed. The combination of external and local
elements with a characteristic grey stone produced a
group of sculptures that is unmistakably Gandharan.
The treatment of the hair and drapery and the
representation of solid flesh are Hellenistic, but the
profusion of jewellery and the departure from the
Apollonian ideal of beauty by the moustache is
purely local. Jewellery, including hair-ornaments, is
one of the ways in which a Bodhisattva (Buddha-to-
be) is recognized in Buddhist sculpture. It originates
from the Buddhist scriptures in which Gautama is
described in his early life as belonging to the family
of a minor ruler and therefore a 'prince'. Since the
religious sculpture of Gandhara created rather than
inherited tradition, it is probable that the appearance
of Bodhisattva figures was based on the dress and
ornaments worn by contemporary nobility. There is
a likelihood, therefore, that this is not only an image
of a deity but an illustration of a type of individual
who could often be seen in the area to the north of
Peshawar in the early centuries AD.
(No. I.S.100-1972)

38 SANDSTONE TORSO OF A BODHISATTVA
India (Sanchi); probably 9th century AD
H. 86cm (2ft 9⅞in)
ROOM 47

This image was not, as it first appears, carved in the round but
formed part of an upright slab, or stele, on which it stood out in high
relief. It is likely to have formed part of a group of three deities showing
the Buddha with the figure from which this torso originally came
(Avalokiteshvara) on one side and a corresponding one (Maitreya) on
the other. It would thus have followed an arrangement that had a long
tradition in India in which one figure balanced another on each side of
the main deity. This was emphasized by the curves given to the torso
here, where the central line runs from the centre of the forehead to the
navel and is then reversed, following the abdomen and the hips to give
the figure a flexed position that combines lightness with solidity. The
delicately modelled surfaces of the upper part of the torso contrast with
the ornaments which help to reveal its form through their curves and
devices, such as the diminishing size of the bells forming the outer
border of the necklace. Jewellery, including diadems and bracelets not
shown here, is conventionally part of the dress of a Bodhisattva
(Buddha-to-be) as an allusion to the aristocratic life of Gautama before
he took up the life of a monk. There can be little doubt that the sculptor
of this torso has admirably combined dignity and compassion in a figure
that is both prince and deity.
(No. I.M.184-1910)

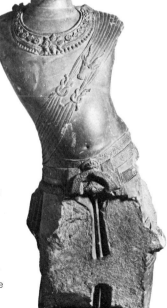

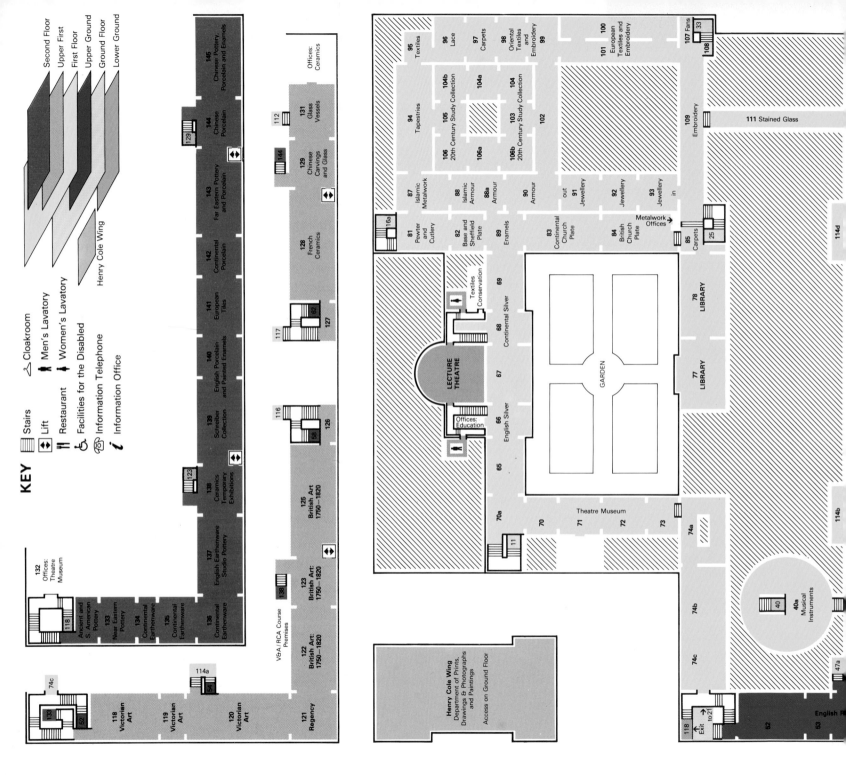

KEY

▦	Stairs
◆▶	Lift
¶	Restaurant
♿	Facilities for the Disabled
☎	Information Telephone
i	Information Office
△	Cloakroom
♀	Men's Lavatory
♂	Women's Lavatory

Second Floor
Upper First
First Floor
Upper Ground
Ground Floor
Lower Ground

Henry Cole Wing

132 Offices: Theatre Museum

118

133 Ancient and S. American Pottery
134 Near Eastern Pottery
135 Continental Earthenware
136 Continental Earthenware

137 English Earthenware Studio Pottery

145 Chinese Pottery Porcelain and Enamels
144 Chinese Porcelain
143 Far Eastern Pottery and Porcelain
142 Continental Porcelain
141 European Tiles
140 English Porcelain and Painted Enamels
139 Schreiber Collection
138 Ceramics Temporary Exhibitions

Offices: Ceramics

112
131 Glass Vessels
144
129 Chinese Carvings and Glass
128 French Ceramics
127
117
126
116
123

125 British Art 1750–1820

122 British Art 1750–1820
123 British Art 1750–1820

V&A / RCA Course Premises

138

74c
133
52

118 Victorian Art
119 Victorian Art
120 Victorian Art
121 Regency

114a
54

95 Textiles
96 Lace
97 Carpets
98 Oriental Textiles and Embroidery
99
100
107 Fans
33
108

94 Tapestries
104b 20th Century Study Collection
104a
104 20th Century Study Collection
101 European Textiles and Embroidery
102
106
105
106a
103
106b 20th Century Study Collection

87 Islamic Metalwork
88 Islamic Armour
88a Armour
90 Armour
91 Jewellery out
92 Jewellery
93 Jewellery in

109 Embroidery
111 Stained Glass
114d

16a

81 Pewter and Cutlery
82 Base and Sheffield Plate
89 Enamels
83 Continental Church Plate
84 British Church Plate
85 Carpets
25

Metalwork Offices

69 Continental Silver
68
67
66
65 English Silver
70a

Textiles Conservation

LECTURE THEATRE

Offices: Education

GARDEN

78 LIBRARY
77 LIBRARY

70 Theatre Museum
71
72
73
74a
74b
74c

11

40
40a Musical Instruments

114b

47a

Henry Cole Wing
Department of Prints, Drawings & Photographs and Paintings

Access on Ground Floor

118 → Exit to 21
52
53 English R

Designed by R. Cotting

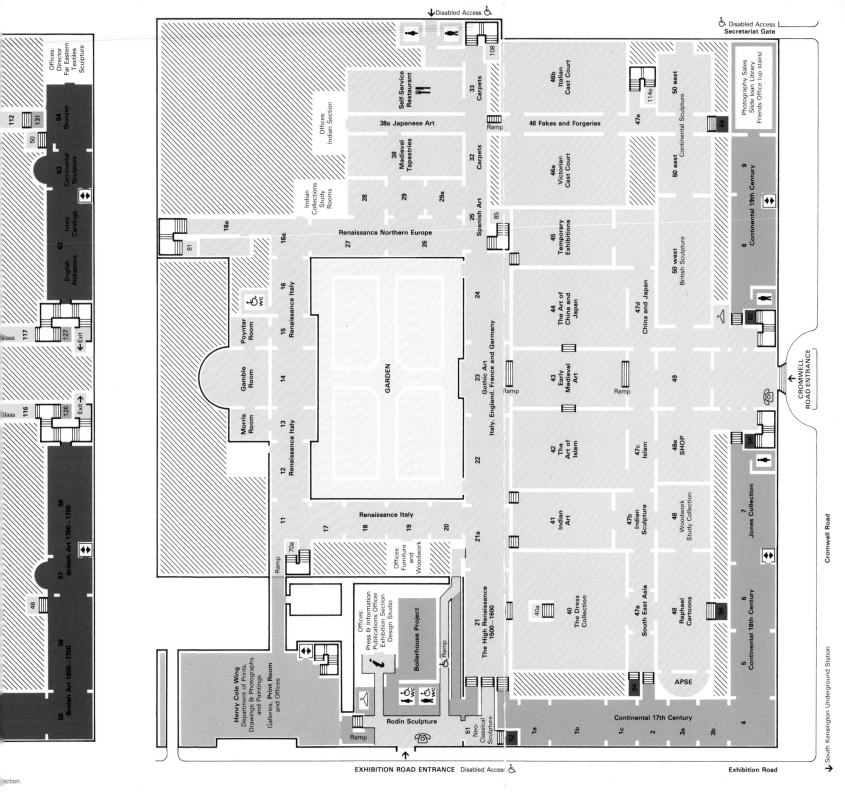

♿ Disabled Access
Secretariat Gate

Offices:
Director
Far Eastern
Textiles
Sculpture

112

50 131

64
Bronzes

63
Continental
Sculpture

62
Ivory
Carvings

English
Alabasters

117
127 ← Exit

116
126 Exit →

Glass

58
British Art 1700–1750

48

57

56
British Art 1650–1700

55

Self-Service
Restaurant

33
Carpets

38a Japanese Art

Offices:
Indian Section

38
Medieval
Tapestries

32
Carpets

Indian
Collections
Study
Rooms

28 29 29a

Ramp

108

46b
Italian
Cast Court

50 east

114e

50 east
Continental Sculpture

46 Fakes and Forgeries

47e

64

Photography Sales
Slide loan Library
Friends Office (up stairs)

46a
Victorian
Cast Court

9
Continental 19th Century

25
Spanish Art

85

16a
16

16e

81

Renaissance Northern Europe

27 26

45
Temporary
Exhibitions

50 west
British Sculpture

8
Continental 19th Century

Poynter
Room

wc ♿

16
Renaissance Italy

15

Gamble
Room

14

24

GARDEN

44
The Art of
China and
Japan

47d
China and Japan

67

Morris
Room

13
Renaissance Italy

23
Gothic Art
Italy, England, France and Germany

Ramp

43
Early
Medieval
Art

Ramp

49

CROMWELL
ROAD ENTRANCE ←

12
Renaissance Italy

22

42
The
Art of
Islam

47c
Islam

48e
SHOP

58

11 Renaissance Italy

70a

17 18 19 20

21a

41
Indian
Art

47b
Indian
Sculpture

48
Woodwork
Study Collection

7
Jones Collection

Ramp

Offices:
Furniture
and
Woodwork

Offices:
Press & Information
Publications Officer
Exhibition Section
Design Studio

Boilerhouse Project

Ramp
♿

21
The High Renaissance
1500–1600

40a 40
The Dress
Collection

47a
South East Asia

48
Raphael
Cartoons

56

6
Continental 18th Century

Henry Cole Wing
Department of Prints,
Drawings & Photographs
and Paintings
Galleries, Print Room
and Offices

i

♿ wc
♿ wc ←

Rodin Sculpture

Ramp

51
Neo-
Classical
Sculpture

54

APSE

5
Continental 18th Century

52

1a 1b 1c 2 3a 3b

Continental 17th Century

4

39 BRONZE FIGURE OF SHIVA NATARAJA
India (Madras); 11th century AD
H. 88.5cm (2ft 11in)
ROOM 47

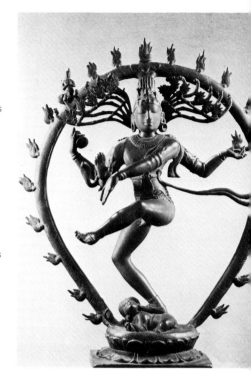

South Indian bronze images were often made to be carried in procession as well as worshipped statically. This corresponds to the sequence of daily rituals observed by some Hindu sects which includes waking the deity up, bathing and feeding it, taking it for a walk and putting it to bed. Occasionally, rituals also include dancing, and this is reflected by the posture of Shiva here, which shows him as Lord of the Dance. This popular image of Shiva illustrated a legend in which he set out to subdue 10,000 heretical holy men who were living in a nearby forest. They responded angrily and evoked a fierce tiger out of a sacrificial fire and sent it against Shiva to kill him. But Shiva merely flayed it and wore the skin as a cape. Next he was attacked by a poisonous snake, but Shiva tamed it and hung it round his neck like a garland. Finally, the hermits employed a fierce black dwarf to destroy him with a club, but Shiva put one foot on his back and performed a magical dance so brilliant that the dwarf and the holy men acknowledged him as their master. Here, Shiva is caught in mid-dance, with one foot on the demon and the other poised for the next step; his long hair flies out at the sides, giving the whole image a feeling of vigorous movement. Bronzes from South India belonging to the Chola period (9th–13th century AD), of which this is an example, are some of the finest ever produced in India, combining delicate modelling with sensitive grace and charm. (No. I.M.2-1934)

40 POTSTONE SCULPTURE OF DURGA AS MAHESHASURAMARDINI
South India (Mysore); early 13th century AD
H. 1.43m (4ft 8¼in)
ROOM 47

This piece of potstone sculpture was one of many that covered almost the whole of the outside of a temple. It is executed in high relief in a florid style that is particularly associated with Mysore temple building during the Hoyshala period. This is expressed most strikingly in the treatment of the decorated arch and the headdress of the main figure. Despite her fearsome appearance, she is an aspect of the benevolent Indian mother goddess and is extremely popular with worshippers. In the incident that is illustrated here, she has to adopt a fearsome appearance in order to defeat a demon on the rampage. This was the buffalo demon who, having laid waste the countryside, turned on the army of the goddess in heaven. She tried several ways of catching him, but each time he escaped by changing his form from buffalo to lion, to armed man, to elephant and back to buffalo again. Making a supreme effort, the goddess mortally wounded the buffalo and then killed the demon, as shown here, just as he was about to escape into another form. Although this story is full of savagery, it is represented with restraint which is expressed by the balanced distribution of the elements of the composition on each side of the motionless central figure. (No. I.S.77-1965)

41 VOLCANIC STONE ALTAR SLAB
East Java; 14th or 15th century AD
H. 81cm (2ft 8in)
ROOM 47

This altar slab shows Krishna and Satyabhama on each side of the Parijata tree which, according to legend, Satyabhama persuaded Krishna to steal from Indra and this led to the great battle between the two gods which Indra lost. On the back, the same scene is shown but with the two figures

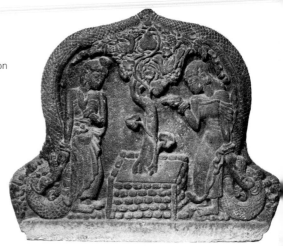

represented symbolically by trees. Slabs such as this are sometimes found in groups of three in Java, where it is thought that they formed the backs of thrones on which the gods were induced to sit during religious ceremonies. This slab has a rather curious history. It was received by the Royal Asiatic Society on 18th May 1832 as a gift from a Mr Palm of Sourabaya, Java. A little later, in 1834, his name was known more precisely as Mr Van der Palm, but no other information was ever obtained either about him or the sculpture, which remained in the possession of the Royal Asiatic Society until it was acquired by the Museum in 1979. At the time it was received by the Society it was thought to represent Adam and Eve, which – except that it was unlikely to have come from a Christian context – probably seemed plausible. However, the guess (if that is what it was) was not so wide of the mark as might be imagined, as the Parijata tree is sometimes regarded as a wish-granting tree, and Krishna was most reluctant to steal it. Although the theft created temporary strife between the two gods, the act did not have the fundamental consequences for Hinduism which the story of Adam and Eve had for Christianity.
(No. I.S.10-1979)

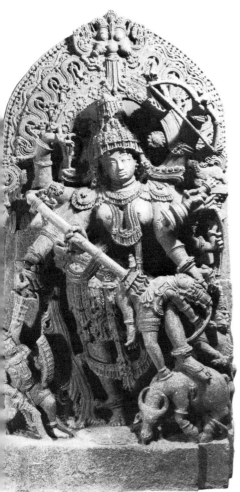

42 THE BODHISATTVA AMOGHAPASHA AND OTHER DEITIES

Painted on cotton cloth
Nepal; c.*1450*
H. 97cm (3ft 2⅛in)
W. 74.5cm (2ft 5⅓in)
ROOM 47

This deity, whose name means 'he of the infallible noose', is still very popular in Nepal, especially among women, and his worship usually takes place on the eighth day of the dark fortnight of each lunar month. He is regarded as being the saviour of those who are afflicted by adversity and of women who are childless. In the ceremonies which form part of his worship, paintings such as this (which is on prepared cloth and would also have had a cloth mount) were hung up and the deity induced to enter them when prayers and offerings of cooked food were made to him. In his middle right hand he holds the noose of his name, which rescues his followers from the buffetings of daily life; on his right stands the goddess Tara in her green version and on his left the goddess Bhrikuti. Above him are four mandalas, and in the surrounding rectangles are illustrated some of the torments from which sufferers might hope to be rescued by Amoghapasha. As the most important figure, he is larger than all the others. The painting is of the highest quality with careful attention to details, such as the foliage decoration of the mandorla surrounding him, and the harmonious use of colour.
(No. I.S. 58-1977)

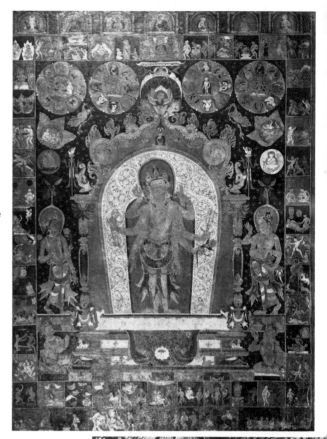

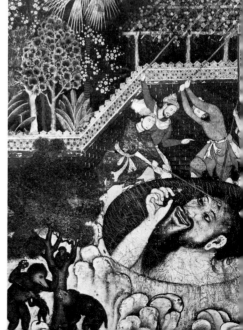

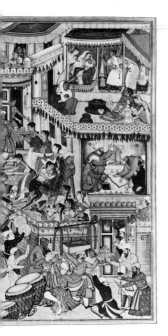

44 CELEBRATIONS AT THE BIRTH OF PRINCE MURAD
A page from the Akbarnama, painted on cotton cloth
Mughal; c.1590
H. 33.4cm (1ft 1⅛in)
W. 19.6cm (7¾in)
ROOM 41

This spirited scene of rejoicings at a royal birth belongs to an illustrated manuscript of the *Akbarnama*, a somewhat fulsome chronicle of the reign of Akbar, greatest of the Mughal emperors, by his friend Abu'l Fazl. In 1576 Akbar's second son, Murad, was born: 'In rejoicing for the rising of this star of fortune, great feasts were held, and largesses bestowed . . . A horoscope was made according to the Greek methods, and another according to Indian rules.' The jubilant atmosphere is brilliantly evoked in this composition, whose high viewpoint allows a view both of the interior of the royal harem, where the mother nurses her child attended by maids, and of the courtyard outside, hung with auspicious plantain leaves, where maids bear trays of food and gifts or sprinkle each other playfully with rosewater. In a chamber to the right the astrologers mentioned by Abu'l Fazl pore over their almanacs, and in the outer courtyard men are dancing to raucous wind and percussion music, while a girl dispenses garlands and a man is delivering a cradle. The composition of this painting is by Bhura, while the faces are by Basawan, one of the great masters of the period, who was much influenced by examples of European art that had reached the Mughal court.
(No. I.S.2-1896 80/117)

43 THE GIANT IN THE WELL
A page from the Hamzanama, painted on cotton cloth
Mughal, c.1570
H. 68.6cm (2ft 3in) W. 54.6cm (1ft 9½in)
ROOM 41

The first Mughal emperors were all men of outstanding character, keen observers of human and natural life and discriminating patrons of the arts. When the second of them, Humayun, returned to India in 1555 from a period of exile in Persia, he brought with him two famous artists from the Persian royal studio. Their first major commission, under Humayun's son, Akbar, was the production of 1,400 large paintings on cloth which were used in the narration of the fantastic adventure stories concerning Amir Hamza, one of the early heroes of Islam. Some 30 to 50 native Indian artists were employed to work on this uniquely ambitious project. Under Akbar's keen eye, a bold synthesis of styles was thus brought about, marrying Persian decorative effects and clarity of construction with Indian vitality of execution and natural observation.

The present example is one of a number acquired by the Museum in the late 19th century after they were found blocking up the windows of a tea-house in Kashmir. At this point in the story, a fire-worshipping Persian giant, Zamurrad Shah, has been pushed into a concealed animal-trap while drunk and gardeners are beating him as he struggles to escape. The violent depiction of his desperate plight is effectively contrasted with the tranquillity of the walled garden, with its flowering trees and laden vines, and counterpointed by the domestic squabble among a family of bears in the foreground.
(No. I.S.1516-1883)

45 THE FREMLIN CARPET
Mughal (Agra or Lahore);
c.1630-40
L. 5.78m (18ft 11½in)
W. 2.44m (8ft)
ROOM 41

The carpet was commissioned by William Fremlin, a prominent official of the East India Company, who served in India from 1626–44, and whose coat of arms appears on it 17 times. The basic layout derives from an East Persian prototype: the field pattern of carnivores and their prey interspersed with fabulous monsters and flowering trees, the borders filled with conventional ragged palmettes and interlacing stems. Though Fremlin went on a mission to Persia in 1637, and while there ordered a carpet for a Goanese dignitary, there seems little doubt that his own carpet is the product of the workshops established at Lahore and Agra in the reign of the Mughal Emperor Akbar (1556–1605), who imported weavers from East Persia. By the time Fremlin commissioned his carpet, the original Persian designs had been modified and infused with a subtle

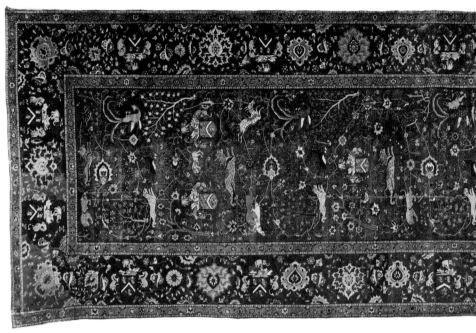

46 SHAH JAHAN'S JADE CUP
India; AD 1650
H. 5.6cm (2¼in)
L. 18.4cm (7¼in)
ROOM 41

This cup carries an inscription dated in the 31st year of the emperor's reign (1657 AD). It is engraved in a small cartouche on the side of the vessel and was probably put on when the cup entered the imperial treasury. It refers to 'The Second Lord or the (auspicious) Conjunction', which was a title adopted by Shah Jahan (1628–58) in homage to his illustrious ancestor Timur, who attributed his military success to his birth under two favourable planets and so called himself 'Lord of the (auspicious) Conjunction'.

The sensuous appeal of the cup is the result of a perfect combination of design and material. Jade was almost unknown in India before the Mughals, but Babur valued it for its magical properties and Jahangir, Shah Jahan's father, was the first of the dynasty to patronize jade carving. This is a difficult technique because the stone, despite its apparent waxlike softness, is so hard that it cannot even be scratched by steel. Yet here the craftsman's skill has created out of such intransigent material a design of smoothly flowing lines that seems

Indianization. Interlacing stem patterns became looser, less dominant, opening up and exposing the field. Individual motifs were placed symetrically, but depicted with increased vivacity and naturalism. The carpet is of woollen pile (Sehna knots) on cotton warps and wefts.

Fremlin's service included two periods at Agra, but there is as yet no means of distinguishing between the carpets of Agra and Lahore. In 1619 the East India Company directors in London were informed that their agents in Agra were obtaining Lahore carpets, which were generally reckoned to be the best.

The long, narrow proportions and deep borders of the Fremlin carpet indicates that it was intended to cover a table, the usual place for displaying such status symbols in Jacobean England, when the floors — even of great houses — were more likely to be covered with rush matting, or left bare.

(No. I.M.1-1936)

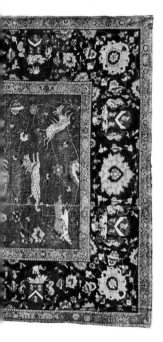

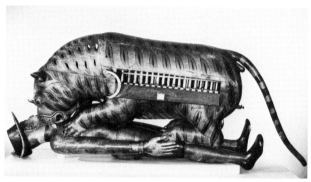

47 TIPU'S TIGER
India (Mysore); late 18th century
L. 1.78m (5ft 10in) W. 6.1m (2ft) H. 7.11m (2ft 4in)
ROOM 47

This unusual object of carved and painted wood, which contains a pipe organ, was captured at the fall of Seringapatam, Mysore, on 4th May 1799. It was originally made in about 1790 for the amusement of Tipu Sultan, ruler of Mysore, and was brought to England in 1808, where it formed one of the chief attractions of the East India Company's private museum. In 1819 it was seen by Keats and inspired several stanzas of his satirical poem *The Cap and Bells*.

It represents a prostrate British civilian (perhaps an employee of the East India Company) being savaged by a tiger. This evidently gave Tipu an outlet for his anti-British sentiments and reassured him that the qualities of a tiger which he saw in himself would eventually enable him to triumph over his enemies. Thus, by turning a handle at the side, the organ is made to simulate a tiger's roar and the cries of the stricken victim, while at the same time a system of rods and levers raises the victim's left arm as if in defence. There is also a button-keyboard which allows music to be performed on the organ within the tiger's body. Judging from the way in which the organ was constructed, it is likely to have been of French manufacture, but the woodcarving and painting are undoubtedly Indian workmanship.
(No. I.S.2545)

to be more associated with modelling than hardstone carving. The subtle proportions of the thin, lobed wall, echoing the shape of a fresh gourd, are offset by the sensitive curve of the handle, which ends in the form of the head of a wild goat and contrasts with the supporting foot, shaped to represent acanthus leaves in low relief radiating from a lotus flower. The effect of these delicate lines, from whichever angle they are seen, is intensified by the play of opalescent light on the surface and a persuasive tactile appeal.
(No. I.S.12-1962)

48 THE GOLDEN THRONE OF
RANJIT SINGH
Lahore; c.1830
H. 94cm (3ft 1in)
ROOM 41

The Golden Throne, made of
wood and resin overlaid with
sheets of beaten gold, is asso-
ciated with Maharaja Ranjit Singh
(1780–1839), 'The Lion of the
Punjab', who unified the warring
factions of the Punjab into the
Sikh nation. The collapse of Sikh
unity after his death was followed
by the Anglo-Sikh wars and
finally, in 1849, by British
annexation of the Punjab. The
throne, referred to in contem-
porary accounts as 'Ranjit's
Golden Chair of State', was
shipped to England for the East
India Company's museum and
eventually transferred to South
Kensington.

The distinctive 'waisted' shape
derives from ancient Hindu
tradition, seen also in the
sculptured lotus thrones of the
gods, and still used for woven
basketwork seats, which may
have furnished the prototype in
remote antiquity. The velvet
cushions are red and yellow, a
colour combination favoured by
Ranjit's dynasty. This was noted
on several occasions by British
visitors, all women, the best
known being Emily Eden, sister of
Lord Auckland, the Governor-
General, who wrote in 1838 of
the Maharaja's thousands of
followers, all dressed in red or
yellow.

Ranjit Singh is depicted in art
occupying a number of different
thrones and 'chairs of state', none
of which can be positively identi-
fied with the Golden Throne. It
does, however, appear in a
portrait of his son, Maharaja Sher
Singh (1807–43), by the Viennese
painter Schoefft, who worked for
several years at the court in
Lahore. (No. I.S.2518)

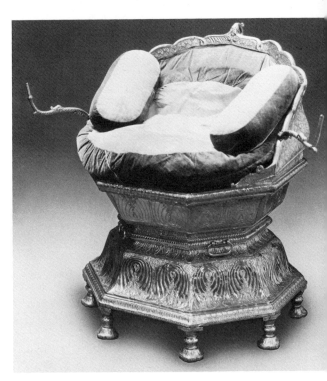

49 THE GLOUCESTER
CANDLESTICK
English; c.1105
H. 58.4cm (1ft 11in)
ROOM 43

This candlestick is an eloquent
witness to the skill of an English
craftsman some 40 years after the
Norman Conquest. It is made of
gilt bronze and was cast in three
pieces by the *cire-perdue* (lost-
wax) process. The decoration
consists of a wild ballet of men
and monsters, whilst an inscrip-
tion states that it was given by
Abbot Peter to the Abbey, now
the Cathedral, of Gloucester over
which he presided from 1104–13.
The candlestick left Gloucester at
an early period, since another
inscription of early 13th century
date states that it was presented
by Thomas de Poche to Le Mans

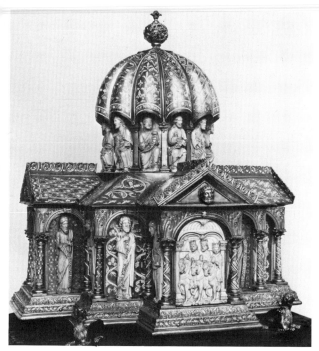

50 THE ELTENBERG
RELIQUARY
Rhenish; late 12th century
H. 54.6cm (1ft 9½in)
W. 50.8cm (1ft 8in) L. 50.8cm
(1ft 8in)
ROOM 43
This reliquary shows the skill of
Rhenish 12th century goldsmiths
in achieving rich effects without
the use of intrinsically valuable
materials. It resembles a Byzantine
church and consists of an oak
foundation mounted with *champ-
levé* enamel and copper-gilt, and
is also decorated with ivory
carvings of Christ and the
Apostles. On the four fronts are
scenes from the life of Christ
(two being modern replacements)
and in the niches are figures of
prophets. It is generally dated
about 1180 and at the time of
the French Revolution was in a
Benedictine nunnery at Eltenberg
(now Hoch-Elten) on the German/
Dutch frontier near Emmerich.
When the nunnery was pillaged, it
was saved by one of the nuns.
She later gave it to a canon of a
neighbouring church, whose rela-
tives sold it on his death in 1841
to a dealer who began to sell the
ivories separately. Fortunately, it
was soon bought by Prince
Florentin of Salm Salm who later
sold it to Prince Soltikoff. It was
bought for the Museum in 1861.
(No. 7650-1861)

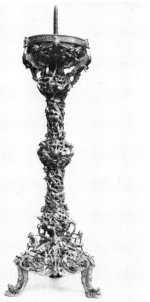

Cathedral. It is said to have been
sold out of the cathedral before
the French Revolution but
remained in that city until pur-
chased for Prince Soltikoff. At the
sale of his collection it was bought
for the Museum in 1861.
(No. 7649-1861)

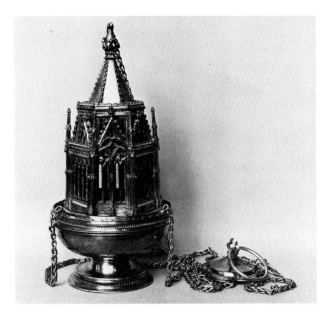

51 THE RAMSEY ABBEY CENSER
English; mid-14th century
H. 27.3cm (10¾in)
ROOM 24

This is the only silver-gilt censer made in England during the Middle Ages which has survived; it compares in date and style with a recently acquired gilt-bronze censer (No. M.123-1978). It was found in 1850 during the draining of Whittlesea Mere, Huntingdon-shire, together with a mid-14th century incense-boat and some 15th century pewter plates. At each end of the incense-boat is a ram rising from waves, and a similar device is stamped on the plates (some of which are in the Peterborough Museum). This device was used as a rebus for the name Ramsey and seems to indicate that the whole hoard once belonged to Ramsey Abbey. The censer and incense-boat were acquired for the Museum in 1923 with the aid of a generous donation from C.W. Dyson Perrins, FSA.
(No. M.268-1924)

52 STUDLEY BOWL
English; late 14th century
Diam. 14.6cm (5¾in)
ROOM 24

The silver-gilt covered bowl would appear to have been intended to supply nourishment and education simultaneously. It is decorated with chased and engraved ornament consisting of part of a black-letter alphabet followed by literal symbols and contractions, as used in contemporary manuscripts. The beauty of form and proportion displayed by this bowl, as well as the skill shown in the execution of the ornamental details, enables one to realize the high degree of technical and artistic excellence attained by medieval craftsmen. It was for a time the property of Studley Royal Church, near Ripon, Yorkshire.
(No. M.1-1914)

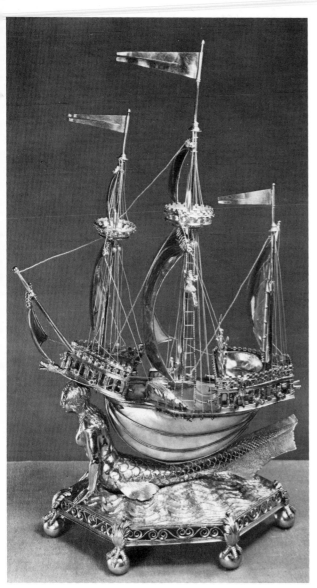

53 THE BURGHLEY NEF
French; 1528
H. 34.6cm (1ft 1⅝in)
ROOM 26

In medieval times the nef served in many foreign countries the function of indicating the position of the host at the dining table, just as the great salt did in England. They were mainly decorative, but some – like the Burghley Nef, which contains a salt-cellar in the poop – served some other purpose. The Burghley Nef bears the Paris mark for 1528 and the mark of Pierre Le Flamand. A mermaid supports on her back the hull of the ship which is formed out of a nautilus shell, but the rest of the vessel is made of silver parcel-gilt. It is a romanticized version of a late medieval ship and its fanciful character is emphasized by the presence before the main mast of the tiny seated figures of Tristram and Iseult playing chess. The nef was bought for the Museum in 1959 from the collection of the Marquis of Exeter. It is thought to have reached Burghley House in 1844 and to have been previously at Cowdray Park.
(No. M.60-1959)

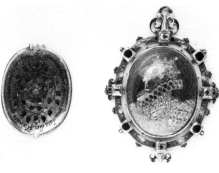

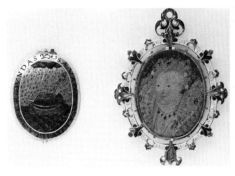

54 THE ARMADA JEWEL
English; c.1588
H. 7cm (2¾in)
ROOM 92

This jewel is of enamelled gold set with diamonds and rubies. Under a convex glass is a profile bust of

Queen Elizabeth I. The back forms a locket which contains a miniature portrait of the Queen dated 1580, the cover being enamelled on the outside with a representation of the storm-tossed Ark. The miniature painting is generally regarded as the work of Nicholas Hilliard (1547–1619), which has been spoilt by retouching at a later date. Hilliard was also, however, an accomplished jeweller and may have been responsible for much of the work. The jewel appears to have been given by the Queen to Sir Thomas Heneage of Copt Hall, Essex, who served as Treasurer during the Armada period. (No. M.81-1935)

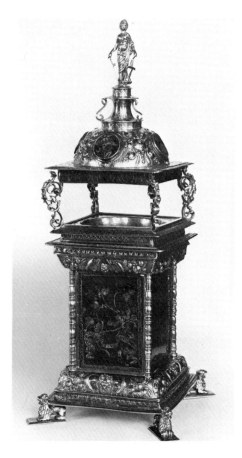

55 THE VYVYAN SALT
English; 1592–93
H. 40cm (1ft 3¾in)
ROOM 52

This piece owes its name to the fact that it was for long the possession of the ancient Cornish family of Vyvyan of Trelowarren. The cover is surmounted by a figure of Justice and mounted upon a removable frame which enables it to remain in position even when in use as a salt-cellar. The silver-gilt portions bear the mark of a goldsmith who stamped his work with the mark WH, a flower and the London hallmark for 1592–93. Much of the attractiveness of the salt is due, however, to the panels and medallions of *verre eglomisé* (glass decorated on the back with colours and foil). The side panels are based on design in Geoffrey Whiney's *Choice of Emblemes*, published in 1586. (No. M.273-1925)

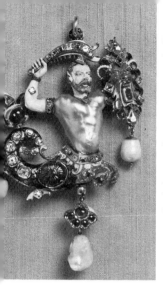

56 THE CANNING JEWEL
Italian; 16th century
H. 10.2cm (4in)
ROOM 92

In the form of a merman brandishing a jawbone, this jewel is a classic example of the virtuosity of Italian Renaissance jewellers. The torso of the figure is formed by a baroque pearl, whilst the remaining parts are of enamelled gold set with rubies, diamonds and pearls. There is no documentary backing for the story that the jewel was a gift from a Medici prince to one of the Moghuls, but it was certainly acquired in India by Lord Canning whilst Viceroy and after his death was bought by his brother-in-law, the first Marquis of Clanricarde. It was presented to the Museum in 1931 by Mrs Edward S. Harkness, when it was sold by the Earl of Harewood to whom it had been bequeathed by the second Marquis of Clanricarde.
(No. M2697-1931)

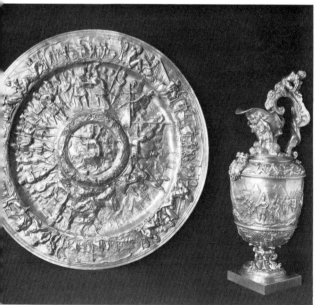

57 EWER AND BASIN
Italian; 1621-22
H. of ewer 53.3cm
(1ft 9in) Diam. of basin 64.1cm
(2ft 1¼in)
ROOM 1C

This is the largest of a set of three contemporary pairs of ewers and basins, all bearing the same coat of arms. Made of silver, the ewer is inscribed with the town mark of Genoa for 1621 and 1622 and the maker's mark, GA over B, probably for Giovanni Aelbosca 'the Belgian'. The basin is also inscribed 1621.

The events embossed on this ewer and basin depict, as the flags show, a joint Genoese and Spanish victory over Venetian troops. It is almost certainly the same subject as was painted in 1615 by Lazzaro Tavarone (1556–1641) on the ceiling of the Grimaldi Palace, Piazza San Luca, Genoa, with the inscription 'G. Grimaldi having defeated the Venetian navy and captured the flag of St Mark and other trophies, being presented to Philip II of Spain.' This fresco no longer survives, but other works by Tavarone suggest that he may have been the designer of this ewer and basin. So far, however, these designs have not been traced, nor is it known precisely what battle is represented, nor whose coat of arms is on all three ewers and basins. The other two, which are embossed with mythological marine subjects, are in the Ashmolean Museum, Oxford, and the Birmingham City Art Gallery.
(No. M.11+a-1974)

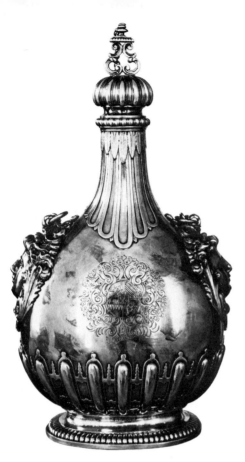

58 THE CHURCHILL BOTTLE
English; 1702–14
H. 40.3cm (1ft 3⅞in)
ROOM 56

This is a typical example of the simple design and fine workmanship of the Huguenot goldsmiths who dominated the English silver trade during the Queen Anne period. It bears the mark of Pierre Platel, one of the most notable goldsmiths of the time, but is not hallmarked. The original owner would appear to have been General Charles Churchill, whose arms – together with those of his wife in pretence – are engraved on one side. After the General's death in 1714, the bottle passed to his brother John, Duke of Marlborough, whose arms are engraved on the other side.
(No. M.854-1927)

59 THE NEWDIGATE
CENTREPIECE
English; 1743–44
H. 25.1cm (9⅞in)
ROOM 123

When the epergne began to come into use in about 1725, it succeeded to the place of honour on the dinner table once occupied by the great salt. This is one of the finest examples carried out in the rococo style and bears the mark of Paul de Lamerie and the London hallmark for 1743–44. It can be used in two ways: either with the four small waiters supported on brackets (as shown here), or with them removed and with ornamental knobs filling the sockets for the brackets. An inscription reads 'The gift of ye Rt Hon Sophia Baroness Lempster to Sr Roger and Lady Newdigate: AD 1743.' The waiters are engraved with the arms of Sir Roger Newdigate impaling those of his wife, Sophia Conyers, granddaughter of Lady Lempster, whom he married in the year of the gift. This piece remained in the possession of the Newdigate family until 1919, when it was acquired for the Museum
(No. M.149-1919)

60 DECANTER
English; 1865
H. 27.9cm (11in) Diam. 17.8cm (7in)
ROOM 118

The decanter is an exuberant piece by one of the greatest designers, architects and antiquarians of the High Victorian period, William Burges (1827–81). It was designed by Burges for James Nicholson and bears the maker's mark of Richard Green for 1865. It consists of a glass bottle mounted in silver, chased and parcel-gilt, in which are set amethysts, opals and other semi-precious stones, as well as Greek and Roman coins. The spout is in the shape of a stag's head and the handle that of a grotesque monster with a horned lion's head and bat's ears, which is copied from the Assyrian ivory pommel of a dagger-hilt of the 8th-7th century BC, owned by Burges and given to the British Museum in 1864.
(No. C.857-1956)

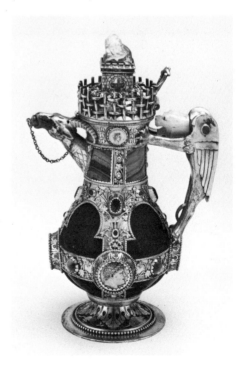

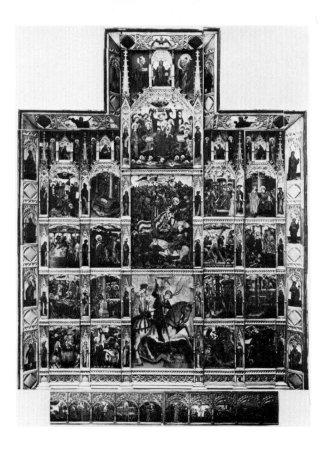

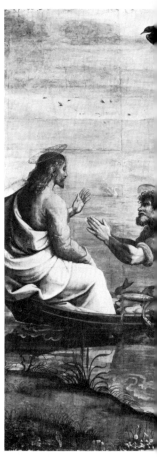

61 ST GEORGE AND THE DRAGON
Tempera and gilt on pine panel
Valencia; ascribed to Marzal de Sas, c.*1410-20*
1.63m x 99.1cm (5ft 4in x 3ft 3in)
ROOM 24

In order to pacify the dragon threatening the city of Silene in Libya, the inhabitants were forced to give up to it a man, woman or child and a sheep every day. Ultimately, the king himself was forced to offer up his own daughter, but she was saved by St George, who happened to be riding by. He spared the dragon and led it back in captivity to the city.

This is one of the central panels of the great altar-piece of St George, painted for the confraternity of Valencian Civic Militia, the *Centenar de la Ploma*. The charm of the figures, the perfect elegance of their dress and postures are typical of the International Gothic style of the period around 1400. These characteristics are in stark contrast to the cruelty and suffering realistically portrayed in the scenes of St George's torture elsewhere on the altar-piece, but such increasingly realistic treatment became typical of later medieval art.
(No. 1217-1864 Neg. no. G.H.1861; central panel)

62 THE RAPHAEL CARTOONS
The Miraculous Draught of Fishes
Italian; 1515
3.35m x 8.23m (11ft x 27ft)
ROOM 48

The seven tapestry cartoons (i.e. full-size working designs) painted in sized colours on paper by Raphael (1483-1520) are part of a set of New Testament scenes commissioned by Pope Leo X in 1515 for tapestries designed for

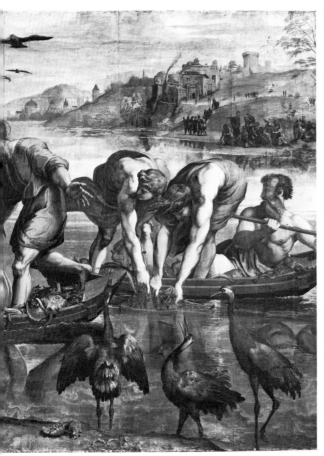

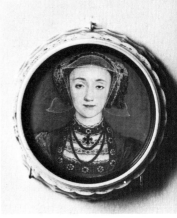

63 ANNE OF CLEVES
Portrait miniature by Hans Holbein
the Younger (1497/8-1543)
English; c.1539
Diam. 4.2cm (1⅔in)
ROOM 406

the Sistine Chapel in the Vatican. In 1516-19 a set of tapestries – now in the Vatican – was made from these cartoons by Pieter van Aelst of Brussels. Most of the cartoons remained in the weaver's studio and various other sets of tapestries were made from them until their designs were known in almost every country in Europe. In 1623 the future Charles I bought the seven extant cartoons for use in the newly-founded tapestry works at Mortlake. The Raphael Cartoons are the most sustained and monumental application of the principles of High Renaissance art to the history of early Christianity and are unrivalled in their clarity of structure and colour, their serenity of mood, and the imaginative force of their interpretation of the Scriptural stories. *Loan H.M.I.* (Neg no. F.F.1972)

Hans Holbein, who was born in Augsburg in 1497/8, first visited England in 1526-28 and settled here in 1532. He became court painter to Henry VIII in 1535, a post he retained until his death in 1543. Although best known for his oil paintings, he also painted miniatures and, indeed, his work in this field between 1532 and 1543 may be said to mark the beginning of the art of portrait miniature in England. When, in 1539, Henry VIII wanted a portrait of his prospective fourth wife, Anne of Cleves, he asked for one from her brother-in-law, the Duke of Saxony. The Duke alleged that his painter – Lucas Cranach – was ill, whereupon Henry sent out Holbein to Düren, near Cologne, to paint the portrait. The picture he painted is in the Louvre, and this miniature was probably carried out at about the same time.
(No. P.153-1910)

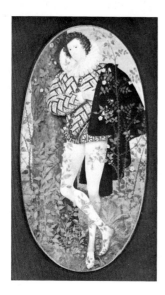

64 AN UNKNOWN YOUTH
LEANING AGAINST A TREE
Portrait miniature by Nicholas
Hilliard (1547-1619)
English; c.1588
13.5cm x 7.5cm (5⅓in x 3in)
ROOM 406

Nicholas Hilliard, the first great
English-born painter of the post-
Renaissance period, was also the
only artist to have left us in his
work a worthy pictorial counter-
part of the literary glories of the
Elizabethan age. Although he is
known to have painted also on oil,
it is for his consummate miniature
portraits, or 'limnings', that he was
outstandingly celebrated during
his lifetime, as he is today. In the
full-length portrait, painted in
about 1588, the lovesick pose
and the symbolisms of the thorn-
bearing rose-tree are underlined
by the Latin inscription at the top
of the miniature, *'Dat poenas
laudata fides'* (My praised faith
causes my sufferings). The identity
of the sitter and the cause of his
melancholy are not recorded, but
the importance of this miniature
suggests that it depicts a member
of the intimate circle of the
Queen, whose favoured painter
Hilliard was.
(No. P.163-1910)

65 LANDSCAPE WITH FIGURES,
'LA HALTE DU CAVALIER'
Oil painting by Lous Le Nain
(1593-1648)
French; undated
54.6cm x 67.3cm
(1ft 9½in x 2ft 2½in)
ROOM 403

The three Le Nain brothers,
Antoine, Louis and Mathieu,
whose work has often been diffi-
cult to distinguish with certainty,
came from Laon to Paris in about
1630, set up studio together
and became members of the
Academie Royale in 1648. Louis
has traditionally been seen as the
most gifted of the three and genre
scenes of this kind have been
attributed to him, though the evi-
dence is inconclusive. His scenes
of peasant life are influenced
by those of his Dutch contem-
poraries but, unlike those, they are
painted without satire, caricature
or amusing anecdote. With its
dominant tones of grey, its frontal
monumental figures, static

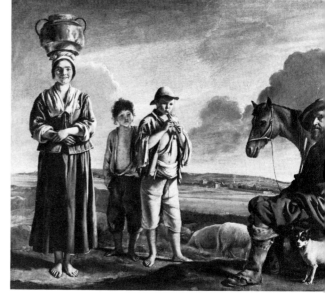

realism and sympathy for its
subjects, this picture is at once
typical of his work and one of his
masterpieces. A replica of this
composition, formerly in the
possession of Pablo Picasso, is
now in the Louvre.
(C.A.I. 17 Neg.no. G.J.5801)

66 APOLLO AND DAPHNE
Pen and wash drawing by
Giovanni Battista Tiepolo
(1696-1770)
Italian; c.1740
29.1cm x 19.5cm (11½in x 7⅔in)
ROOM 302 or the PRINT ROOM

Although not used in the final
scheme for the decoration of the
Palazzo Clerici in 1740, the
Apollo and Daphne is stylistically
and conceptually similar to draw-
ings that certainly are connected
with that project. It is derived
loosely from a sculptural group of
the same subject by Bernini at the
Villa Borghese and shows how
Tiepolo, at the beginning of his
most prolific creative period,
learned the vocabulary of rococo
design and adapted it to his own
purposes. There is no evidence
that drawings of this kind were
ever taken out and used by
Tiepolo for a painting, but they
were carefully preserved, bound
in this instance into one of the two
albums (*Vari Studi e Pensieri*)
which have ended up, more or
less intact, in the Museum. The
326 drawings contained in the
albums form a fair proportion of
the contents of Tiepolo's studio
just before his departure in 1762
for Madrid. A selection is normally
on display with the Jones Collec-
tion in Room 5.
(No. D.1825.75-1885
Neg. no. 79572)

67 MADAME DE POMPADOUR
Oil painting by Francois Boucher (1703-70)
French; 1758
72.4cm x 57.2cm (2ft 4½in x 1ft 10½in)
ROOM 6

Jeanne Antoinette Poisson, Madame d'Etioles
(1721-64), became Louis XV's mistress in 1745
when she was created Marquise de Pompadour,
and she retained a position of great power at Court
until her death in 1764. She knew Boucher when
she was still Madame d'Etioles and from the time of
her advancement she became his most important
patron. Boucher was renowned for his book
illustrations, tapestry designs and decorative painting
well before 1745. Yet the patronage of Madame de
Pompadour raised him to peaks fo fame that
culminated in his appointment as *Peintre du Roi* in
1765. This picture, which is signed and dated
1758, is one of about eight known portraits painted
by Boucher of Madame de Pompadour. Others are
in the Wallace Collection, in the Louvre and in the
National Gallery of Scotland.
(No. 487-1882)

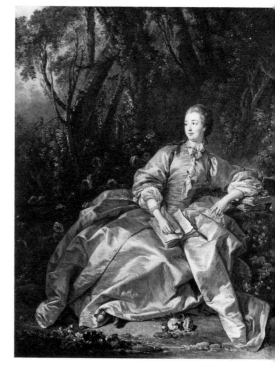

68 KIRKSTALL ABBEY
Watercolour by Thomas Girtin
(1775-1802)
English; undated
30.5cm x 51.1cm (1ft x 1ft 8⅛in)
ROOM 302 or the PRINT ROOM

Girtin's drawing of Kirkstall Abbey at evening is one of his most famous works, epitomizing both his precision as an architectural and topographical draughtsman and his extraordinary powers of emotional self-presentation. Girtin, who died when he was 27, was already being spoken of as a genius by contemporaries, a reputation gained by work in the 'minor' medium of watercolour. It was the readiness of artists like Girtin to use watercolour as the principle means of artistic expression that gives the medium its special importance in British art history. A changing selection of drawings, intended to be historically representative, is always on view in the Museum; any particular piece not on show may be seen on application at the Print Room between 10.00 and 16.30 on weekdays (except Fridays) and Saturdays.

70 FLATFORD MILL FROM A
LOCK ON THE STOUR
Oil painting by John Constable
(1776-1837)
English; c.1811
24.8cm x 29.8cm
(9¾in x 11¾in)
ROOM 603
　　Early in his life Constable set
himself the task of becoming a
'natural painter' of landscape and,
however modest this ideal may
seem to us now, his accom-
plishment of it was to have far-
reaching effects on the history of
European landscape painting. One
of Constable's most important
innovations in the sphere of
technique was his consistent use
of the oil-sketch in working direct
from nature. The Isabel Constable
Gift is remarkably rich in such
sketches, and the present
example is among the most
brilliant of the series. There is
reason to date it about 1811, fairly
early in the artist's career; the
colour is intense and powerful and
the execution fluid. It represents a
scene near East Bergholt,
Constable's birthplace on the
Suffolk-Essex borders. Through-
out his life he remained deeply
devoted to this part of East Anglia
and it provided constant material
and inspiration for his art.
(No. 135-1888; GR 103)

69 THE TWO GREAT TEMPLES AT PAESTUM
Watercolour by John Robert Cozens (1752-97)
English; 1782
24.5cm x 36.8cm (9⅝in x 1ft 2½in)
ROOM 302 or the PRINT ROOM
　　Cozens was one of the most accomplished and
original of the early watercolour painters. Nearly all
of his watercolours can be linked with one or other
of his continental journeys. This is one of the finest
examples from the second tour, of 1782, when he
produced 94 watercolours for his patron William
Beckford. It embodies the melancholy 'pleasing
sadness' of Italy (Beckford). In the 18th century
Paestum, recently discovered, was a popular tourist
centre, but Cozens chose his viewpoint carefully to
eliminate any visual confusion. He created instead a
simple composition seen at sunset in which a mood
of poignant desolation is predominant.
(No. P.2-1973)

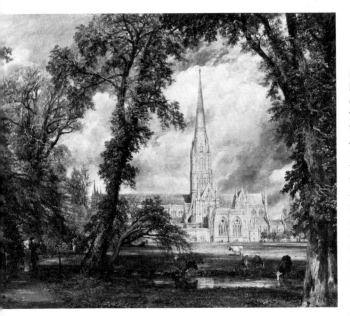

71 SALISBURY CATHEDRAL
FROM THE BISHOP'S GROUNDS
Oil painting by John Constable
(1776-1837)
English; c.1821-23
87.6cm x 1.12m
(2ft 10½in x 3ft 8in)
ROOM 603

Constable paid his first visit to
Salisbury in 1811, to stay with his
old friend Bishop Fisher, and it
was a drawing made on that
occasion which he used to
establish the composition of his
later painting of the cathedral.
It was a commission from the

Bishop (who is to be seen, with
his wife, in the foreground), and
occupied the artist from some two
years between 1821 and 1823,
when it was exhibited at the Royal
Academy. Afterwards Constable
made two other commissioned
versions of the composition, and
there exist several others in
addition with claims to rank as
replicas or sketches. It seems that
after the Bishop's death Constable
brought back the present – and
original – version from his friend
Archdeacon John Fisher (the
Bishop's nephew): at all events, it
figured in his executors' sale in
1838, when it was bought for
John Sheepshanks. It came to the
Museum in 1857 with the
remainder of the Sheepshanks
Gift, and provides one of the focal
points of the Constable Collection,
the largest and most comprehen-
sive holding in the world of this
artist's work.
(No. F.A.33 Neg. no. G.C.1953)

72 DISAPPOINTED LOVE
Oil painting by Francis Danby (1793-1861)
English; 1821
60.3cm x 81.3cm (1ft 11¾in x 2ft 8in)
ROOM 219
This dramatic scene of a lovelorn girl in the river
bank landscape invites comparison with a similar
subject, Millais' *Ophelia* (Tate Gallery). In its exact
representation of a particular spot, it foreshadows
the Pre-Raphaelites' obsessive attention to detail.
The girl had been abandoned or rejected by her
lover: this is apparent from the clues strewn about
her – the miniature of a young man, an open wallet
with a letter and torn scraps of paper. Her own dis-
traught demeanour and the overt symbolism of the
painting suggest that, like Ophelia, she is about to
take her own life in the waters of the river.
(No. F.A.65)

73 THE OLD SHEPHERD'S CHIEF MOURNER
Oil painting by Sir Edwin Landseer (1802-73)
English; 1837
45.7cm x 61cm (1ft 6in x 2ft)
ROOM 218
 This is one of the most famous of Landseer's
paintings – it established his reputation – and it has
come to represent the popular notion of Victorian
sentimentality. It expresses in its narrative all those
qualities most esteemed by the Victorians: rustic
piety, honourable old age, the dignity of rural
poverty and, above all, the value of loyalty and
fidelity, expressed in the dog's devotion to its
master. Ruskin eulogized the work as 'one of the
most perfect poems or pictures which modern times
have seen.' Painted in 1837, the year of Queen
Victoria's accession, it was the forerunner of many
more 'doggy' pictures by Landseer.
(No. F.A.93)

74 THE SONNET
Oil painting by William Mulready (1786-1863)
English; 1839
35.6cm x 30.5cm (1ft 2in x 1ft)
ROOM 217
 Widely regarded as Mulready's masterpiece by
19th century critics, including F.G. Stephens, *The
Sonnet* has remained one of the characteristic
images of British art in its period. All Mulready's
academic training, his highly developed graphic
skills and repertoire of life-class training, are brought
to bear on a modern genre subject, imbuing it
with the monumentality and high seriousness
conventionally reserved for heroic themes. That
was admired, but the colouristic boldness of the
treatment shocked some critics who attacked
Mulready's 'unnatural' and archaicizing palette ten
years before the Pre-Raphaelite Brotherhood
aroused similar misgivings.
 The picture was bought by the artist's friend and
patron John Sheepshanks, and hangs in the
collection which he presented to South Kensington
in 1857 as the foundation of a National Gallery of
British Art.
(No. F.A.146 Neg. no. 59110)

75 NEGERKOPF
Watercolour by Emil Nolde
(1867-1956)
German; c.1913-14
47cm x 34.6cm
(1ft 6½in x 1ft 1⅝in)
ROOM 302 or the PRINT ROOM
 This is one of the few surviving
heads painted by Nolde when he
accompanied an official expedition
to German New Guinea in 1913-
14. Apart from its own formal
qualities and visual impact, the
image is of historical interest as
showing the use of exotic subject
matter by Expressionist artists in
Germany. The drawing also
demonstrates, in its technical
subtlety, Nolde's delicate expertise
in handling the watercolour
medium, an expertise as con-
spicuous in its different way as
Cezanne's.
(No. P.11-1973 Neg. no.
G.C.3728)

76 STILL LIFE
Oil painting by Alexandra Exter (1882-1949)
Russian; c.*1914-15*
33cm x 25cm (1ft 1in x 9⅞in)
ROOM 302 or the PRINT ROOM
 The development of Cubism by Picasso and
Braque transformed the visual arts in the 20th
century: traditional rules of perspective and illusion
were abandoned in favour of fragmented forms,
depicting an object as it is known to be, rather than
as it appears from a single view. These principles
were quickly assimilated by the European avant-
garde. This still life by Exter (a Russian who had
studied and worked in Paris) employs the familiar
Cubist motif of a musical instrument amid studio
paraphernalia on a table-top. The composition is
presented as a construction of flat angled planes in
bright clear colours, showing the influence of
Cubism's later decorative phase.
(No. P.22-1976)

77 FOUR KNOTS SERIES,
NO. 6
Collage by Richard Smith (b.1931)
English; 1975
57.2cm x 57.2cm
(1ft 10½in x 1ft 10½in)
ROOM 302 or the PRINT ROOM
 The avant-garde of the 1960s
and 70s theorized that 20th
century art had evolved – and
should evolve – in the direction of
an ever more explicit declaration
of its essence. The *Four Knots
Series* seeks to demonstrate the
nature of visual language and, at
the same time, to point up the
paradox of Minimal art which
stressed two-dimensionality –
flatness – as an essential property
of painting. By the use of folds
and string the painting is distorted
from a flat plane into a three-
dimensional object. The string and
knots also allude to the packaging
theme which had dominated
Smith's paintings, and much Pop
Art, in the 1960s.
(No. P.24-1979)

78 SOFT SCREW IN WATERFALL
From a series of 8 lithographs entitled *Soft Screw* by
Claes Oldenburg (b.1929)
American; 1976
1.22m x 90.2cm (4ft x 2ft 11½in)
ROOM 302 or the PRINT ROOM

The representation of hard mechanical objects
(typewriters, light switches and motor cars) as soft
forms imbued with sensuality is one of Oldenburg's
preoccupations, but he permits rather than enforces
the sexual interpretation of his work. Of the screw,
he himself has said, 'With its spiral (it) is a basic form
and that is why I was drawn to it. I have located it in
a humble object – the common hardware screw
which . . . I developed . . . into an ideal and typical
version not necessarily functional.' The scale of the
prints was suggested by some charcoal drawings
(later destroyed) which the artist made while being
filmed at work. When drawing the lithographs he
tried to relive the urgent intensity of the original
situation.

The Museum has always collected prints by living
artists of all nationalities. The aim is to represent
every aspect of contemporary printmaking. Olden-
burg works mainly in the USA where the series of
lithographs was printed and published by the
internationally respected Los Angeles firm. Gemini
G.E.L., in 1976.
(No. E.758-1976 Neg. no. G.F.4968)

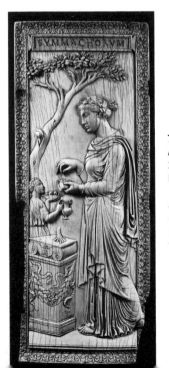

79 THE SYMMACHI PANEL
Roman; late 4th century
29.8cm x 12.1cm (11¾in x 4¾in)
ROOM 43

It was the custom in late
antiquity to issue ivory diptychs to
commemorate special events or
promotions to high office. One of
the most beautiful, now divided
between this Museum and the
Musée de Cluny in Paris, was
carved either to celebrate a
marriage between two Roman
families, the Nicomachi and the
Symmachi, or, since the families
were already closely related, the
profession of a priestess. The relief
in this Museum represents a
Priestess of Bacchus making an
offering before an altar of Jupiter.
The diptych is a reminder that in
spite of the official recognition of
Christianity by Constantine the
Great in 312-13 and the establish-
ment of a Christian capital, a New
Rome, at Constantinople in 330,
the Old Rome still clung
tenaciously to the pagan gods.
(No. 212-1865)

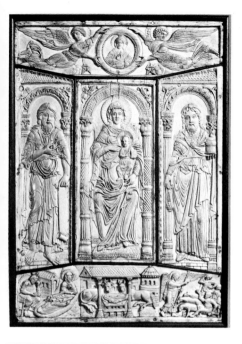

80 THE LORSCH BOOKCOVER

Carolingian; 9th century
38.1cm x 26.7cm (1ft 3in x 10½in)
ROOM 43

The key to the revival of the arts under Charlemagne, crowned Emperor of the West in Rome on Christmas Day 800, lies in the acceptance of the Mediterranean heritage by a northern barbarian. The intention was to recreate a past civilization, but inevitably – in spite of the careful study of late antique, Byzantine and Italian models – this intention was transformed by the northern imagination. Two superb examples of the ivory carvings executed under Carolingian patronage are now divided between this Museum and the Vatican: they originally formed the front and back covers of a Gospel Book from Lorsch. The Vatican relief depicts Christ treading the beasts between two angels; above, two angels bear a cross within a medallion; below, the Magi appear before Herod and bear gifts to the Virgin and Child. On the relief in this Museum (originally the front cover of the Gospels), the Virgin and Child are enthroned between St John the Baptist and Zacharias, the last prophets to proclaim the Salvation of Mankind before the ministry of Christ; above two flying angels hold a medallion of Christ, and below are shown the Annunciation to the Shepherds and the Nativity.
(No. 138-1866)

81 IVORY STATUETTE OF THE VIRGIN AND CHILD

Byzantine; late 11th or 12th century
H. 32.4cm (1ft 0¾in)
ROOM 43

The East Romans at Constantinople believed their city to be under the special protection of the Virgin. The icon of the Virgin Hodegetria (showing the Way) was held in particular veneration. Supposed to have been painted by St Luke, to have been sent in the 5th century by the Empress Eudocia to her sister-in-law, the Empress Pulcheria, hidden in the 8th and 9th centuries during the Iconoclast Controversy, this icon preceded the Emperor Michael VIII Paleologus when, after the collapse of Latin rule in 1261, he entered the reconquered capital to the shouts of the jubilant Greeks. The image was reproduced in mosaic, in metalwork, in manuscript illumination and in ivory. The statuette in the Museum is, however, unique; it is the only Byzantine ivory carving in the round which has survived from medieval times.
(No. 702-1884)

83 THE ASCENSION
Marble relief by Donatello (1386-1466)
Italian; c.*1427-32*
40.6cm x 1.14m (1ft 4in x 3ft 9in)
ROOM 16
This relief of The Ascension, with Christ giving the Keys to St Peter, is the most important example of Italian sculpture in the Museum. It makes use of the low relief, known as *rilievo stiacciato,* which was introduced into Florentine sculpture by Donatello and later, in the hands of Desiderio da Settignano and other sculptors, gave rise to many masterpieces. This was the most exacting, most subtle and most intimate technique used by Renaissance sculptors. The relief was probably carved by Donatello between 1427 and 1432 and both the composition and the figures reveal the influence of the frescoes painted by Masaccio (d.1428) in the Church of the Carmine at Florence. This relief exemplifies the narrative genius which makes Donatello the greatest Italian sculptor, perhaps even the greatest Italian artist, of the 15th century.
(No. 7629-1861)

82 THE SOISSONS DIPTYCH
French (Paris); late 13th century
32.4cm x 23.2cm (1ft 0¾in x 9⅛in)
ROOM 24
In the Romanesque period all forms of art were made subordinate to architecture. Sculpture was conceived, for the most part, in an architectural setting. This principle continued in the 13th century and may be seen magnificently developed on the great west façades of the French cathedrals. This distinguished ivory relief, formerly in the Cathedral Treasury at Soissons, presents the scenes of the Passion before a Gothic façade like a mystery play performed before the Cathedral of Notre Dame in Paris — and the fact that the players are in contemporary costume was intended to give the scenes greater actuality. The style of the diptych typifies many of the characteristics of Gothic art: an increased naturalism, a flowing line, delicate, elegant execution, and a tendency to see the whole world in a microcosm.
(No. 211-1865)

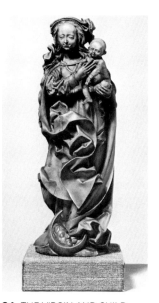

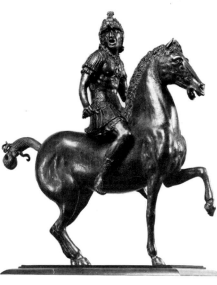

85 SHOUTING HORSEMAN
Bronze statuette by Andrea
Briosco, called Riccio (d.1532)
Italian; c.1505-9
H. 33.7cm (1ft 1¼in)
ROOM 12

Riccio, who spent most of his
working life in Pudua, was
perhaps the greatest exponent of
the art of the bronze statuette of
the Italian Renaissance. His art
draws on that of Donatello and of
Mantegna and he evolved for the
bronze statuette a new role as a
vehicle for the expression of
profound human insights. This

84 THE VIRGIN AND CHILD
Boxwood statuette by Veit Stoss
(*c.*1447-1533)
German; undated
H. 20.3cm (8in)
ROOM 26

The incipient naturalism current
in French Gothic style was taken
to an extreme by German artists
working in the 15th and 16th
centuries. In this superb boxwood
statuette no concession is made
to ideal beauty in the features of
the Virgin, who is presented as a
German peasant, nor in those of
the Child with its ugly, puckered

face and protruding ears. Caught
in a private gale of wind, the folds
of drapery surge about the body
with a boldness and vigour typical
of the artist's harsh, decided style.
For all the bluntness of approach
to this vision of the Mother of
God, the delicacy of carving,
directed by a profound spirit of
devotion, determines a master-
piece of late Gothic German art.
(No. 646-1893)

statuette, which expresses the
violence and terror of the battle-
field, ranks as one of his greatest
masterpieces in the genre. It
seems to show a strong influence
from Leonardo da Vinci, whom
Riccio met in Florence in 1504
while he was engaged on the
great fresco of the Battle of
Anghiari. Closely related to a
series of bronze reliefs with scenes
from the Legend of the True
Cross, which Riccio completed for
the Church of the Servi in Venice
in about 1509, it was probably
made in the years 1505-9.
(No. A.88-1910)

86 A SLAVE
Wax model by Michelangelo
(1475-1564)
Italian; c.1516
H. 16.5 (6½in)
ROOM 21
 There is a close connection
between this little sculptor's model
and one of the great unfinished
figures, known as the *Young
Slave*, which Michelangelo created
for the tomb of Pope Julius II. As
is well known, the tomb was left
incomplete and the *Young Slave*,
together with three other figures
of slaves, is now in the Accademia
at Florence. A number of surviving
wax models have, with varying
cogency, been ascribed to
Michelangelo. This belongs
among the very few which, it is
possible to believe, may really be
by his hand.
(No. 4117-1854)

87 SAMSON SLAYING A PHILISTINE
Marble group by Giambologna (1529-1608)
Florentine; c.1562
H. 2.10m (6ft 10⅝in)
ROOM 21
 The most important sculptor of the second half of
the 16th century, Jean Boulogne from Douai,
known to the Italians as Giambologna, spent most
of his working life in Florence in the service of the
Medici family. The *Samson*, the earliest of his
marble groups, is his only substantial work to have
left Italy. Commissioned by Grand Duke Franceso

de'Medici, it was nearing completion in 1562 and was later set up as a fountain in Florence. In 1601 the entire fountain was sent to Spain as a gift to the Duke of Lerma, the Prime Minister, and in 1623 the central group was presented to Charles, Prince of Wales, later King Charles I, on his visit to Spain.

The daringly original open composition of the group makes it a turning-point in the history of European sculpture. The technical virtuosity is extraordinary: this great marble group is treated with all the lightness and freedom of a bronze statuette. (No. A.7-1954)

88 NEPTUNE AND A TRITON
Marble group by Lorenzo Bernini (1598-1680)
Italian; c.1620
H. 1.84m (6ft 0½in)
ROOM 48

Neptune and a Triton is the only large-scale group by Bernini in any Museum outside Italy. Commissioned in about 1620 by Alessandro Peretti, Cardinal Montalto, to stand at the upper end of a large pond in his garden in Rome, the group remained in this position until 1786, when it was sold with other statues to Thomas Jenkins. It was re-sold to Sir Joshua Reynolds and in 1794 was sold again by his executors to Charles Pelham, first Lord Yarborough.

In the career of Bernini the *Neptune and Glaucus* (as it has also been called) occupies an intermediate position between the celebrated groups of *Pluto and Proserpine* and *Apollo and Daphne* in the Villa Borghese. The group was one of the celebrated sights in Rome and was reproduced in paintings and engravings. By means of these and through direct study it exercised a profound influence on Baroque sculpture elsewhere in Europe. (No. A.18-1950)

89 HANDEL
Marble statue by Louis-Francois Roubiliac
(1705-62)
English; 1738
H. 1.35m (4ft 5¼in)
ROOM 50

Roubiliac has been called the finest sculptor ever to have worked in England. A French Protestant from Lyons who came to England soon after 1730, he is certainly one of the most original sculptors of his age and a leading exponent of the rococo style. His *Handel*, which was his earliest major commission in England, being ordered for Vauxhall Gardens in 1738, is something of a landmark in the history of sculpture: it is the first statue in Europe to a living artist and one of the first sculptures which can truly be called rococo. Acknowledged as the best portrait ever done of the great composer, it combines an informal realism with amusingly handled allegory. Handel, unbuttoned and in his dressing-gown, is represented as Apollo. The surface is handled with astonishing sensitivity and brilliance. It is broken up into innumerable small facets over which light ripples, giving the effect of a living presence. (No. A.3-1965)

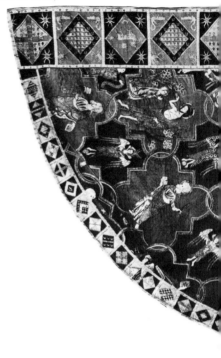

90 CUPID AND PSYCHE
Terracotta group by Claude-Michel, called Clodion
(1738-1814)
French; undated
H. 58.7cm (1ft 11⅛in)
ROOM 6

Although Clodion was a skilled worker in marble and bronze, his fame endures through his exquisitely sensuous terracotta groups. Usually representing a bacchic or amatory subject, they are modelled with a softness and delicacy which have never been surpassed. It must not be assumed, however, that every terracotta group bearing the

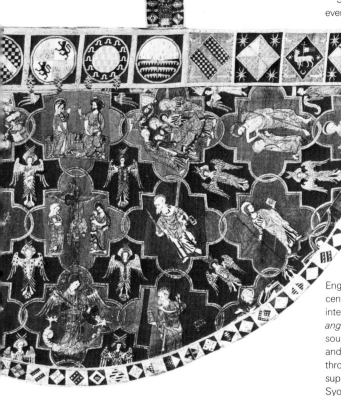

91 THE SYON COPE
English; early 14th century
L. 1.42m (4ft 8in) W. 2.92m (9ft 7in)
ROOM 23

Some of the finest embroidery ever made was produced in England in the 13th and 14th centuries. This needlework, internationally famous as *opus anglicanum* or 'English work', was sought after by the great prelates and potentates of the time throughout Western Europe. The superb vestment known as the Syon cope was made early in the 14th century for an unidentified priest whose portrait appears twice near the upper border or orphrey. The entire surface of the cope is covered with embroidery in silk, silver and gold threads, depicting Biblical scenes, the twelve Apostles and seraphim; the orphreys show the coats of arms of great English families. The vestment was formerly in the possession of nuns from the Bridgettine convent founded by Henry V at Syon, near London, who, after an exile of nearly 300 years on the Continent, returned with it to England early in the 19th century.
(No. 83-1864)

inscription 'Clodion' was modelled by Claude-Michel himself. Quite apart from the numerous imitations and copies which were made in the second half of the 19th century, it is certain that some of the production of the Clodion workshops must have been executed by other hands. The group of *Cupid and Psyche* is an undoubted masterpiece by Clodion and a perfect example of the slightly idealized eroticism in which he excelled. Its date is unknown, though it probably belongs to his later years.
(No. A.23-1958)

92 THE ERPINGHAM CHASUBLE

Italian silk; c.1385-1415 English embroidery; c.1400-15

L. 1.18m (3ft 10½in) W. 76.8cm (2ft 6¼in)
ROOM 43

The coat of arms on this chasuble shows that it was made at the command of Sir Thomas Erpingham (*d*.1428), the knight immortalized in Shakespeare's *Henry V* at the battle of Agincourt. The rich silk, with its lively pattern of camels laden with panniers of flowers, was imported into England from Northern Italy. Its style suggests a date between 1385 and 1415. The embroidered orphrey (border) is less accomplished than earlier *opus anglicanum*, 'English work', famous throughout Europe, and is closely comparable to other orphreys produced in the early 15th century, probably in London.
(Neg. no. F.G.1676 T.256-1967)

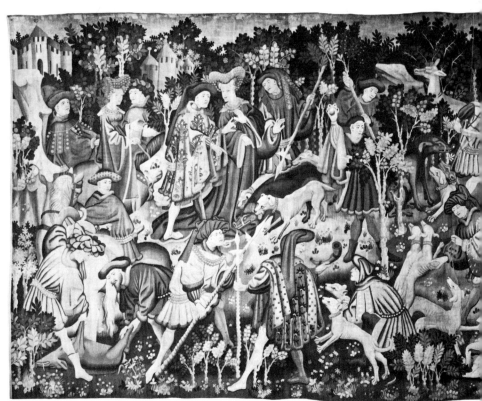

93 THE DEVONSHIRE HUNTING TAPESTRIES
Detail from the Bear and Boar Hunt
English; c.1425-50
4.27m x 10.67m (14ft x 35ft)
ROOM 38

Most of the more important Gothic and early Renaissance tapestries
in the collection are shown in Room 38. Among them are four large
tapestries with hunting scenes, formerly belonging to the Dukes of
Devonshire. Although superficially similar, the tapestries show
considerable differences in the styles of costume depicted and in the
drawing of flowers and plants. The earliest of the four designs is that of
the *Boar and Bear Hunt,* with gaily dressed courtiers of the 1420s.

Cartoons – the full-scale designs from which weavers worked – were
owned by the workshop and updated in detail until worn out or the
market failed. These endlessly pleasurable hunting scenes must have
been woven innumerable times and it is sheer chance that these four
survived together. They have been extensively repaired, having at one
time been cut and hung as curtains, but even so they are among our
most precious possessions.
(Nos. T.202 to 205-1957)

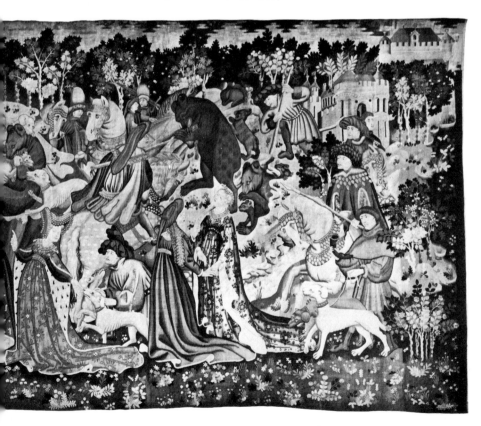

94 THE ARDABIL CARPET
Persian; 1539-40
L. 10.52m (34ft 6in) W. 5.33m (17ft 6in)
ROOM 42

Under the Safavid dynasty in 16th century Persia some of the finest
and most beautiful carpets were woven. This carpet is one of a pair (the
other is in Los Angeles) and is associated with the tomb-mosque of
Sheikh Safi-ed-Din at Ardabil on the Caspian Sea. It was acquired by an
English firm and sold to this Museum at the end of the last century. This
great carpet is very finely knotted in lustrous woollen pile on a silk warp
and weft. Only 13 colours are used to achieve the design, with its
central medallion and 16 pendants on a glowing dark blue ground
covered with intertwining floral stems. The centre of the great yellow
medallion may represent a lotus pond; two mosque lamps hang at
either end of the medallion while the inscription at one end gives the
name of the master-weaver Maksud of Kashan and the date.
(No. 272-1893)

95 APPLIED WORK BEDHEAD
French; c.1550
H. 1.22m (4ft) W. 1.70m (5ft 7in)
ROOM 21

This grotesque bedhead is a superb example of a style which was to dominate French ornament design during the third quarter of the 16th century and which had been introduced to France by Italian artists working at the Palace of Fontainebleau in the 1540s. The grotesque style had its origins in the Roman wall and ceiling decorations uncovered in Rome at the end of the 15th century. Since the Roman sites were below the then ground level, they were seen as caves or grottos – hence the name.

The bedhead, which once formed part of a set comprising curtains, valances, tester and probably a coverlet, is worked with great skill and delicacy in an appliqué of satin on satin, with embroidered details and couched cord decoration. Fragments from the valances are in the Musée des Arts Décoratif, Paris. Similar sets are recorded in the French royal inventories and a valance in the same technique, bearing the monogram of Henri II and Diane de Poitiers, is in the Louvre. (Neg. no. G.K.3163 No. T.405-1980)

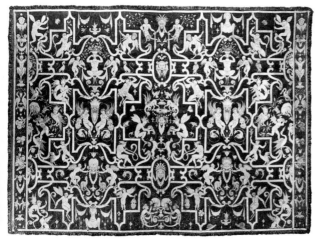

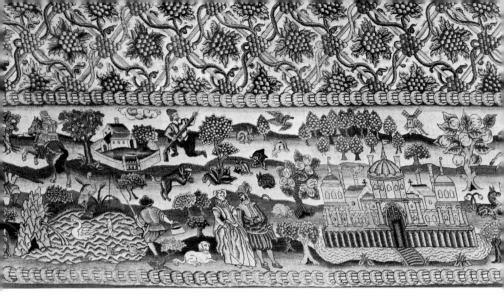

96 THE BRADFORD TABLE
CARPET (detail)
English; early 17th century
L. 3.96m (13ft) W. 1.75m
(5ft 9in)
ROOM 53

This table carpet, acquired from the collection of the Earl of Bradford, is one of the finest surviving pieces of Elizabethan embroidery. It is worked in tent-stitch — about 400 stitches per 6.5 sq cm (1sq in) — in coloured silks on canvas. The formal vine-trellis pattern of the centre contrasts agreeably with the lively border consisting of landscape peopled with men and women engaged in country pursuits, such as boar and stag-hunting, fishing, or merely walking about and enjoying the fresh air. Country houses, farms and mills are also depicted and scattered about are other favourite motifs of the Tudor embroideress — fruit-trees, flowers and animals. Although the same design appears on both the upper and lower border, the embroideress has amused herself by devising different colour schemes for each to give variety. (Detail G.D. 4652 No. T.134-1928)

98 'LORD AND LADY CLAPHAM'
Dressed and accessorized wooden dolls
English; c.1690
H. 55.9cm (1ft 10in)
ROOM 40

97 'TURKEYWORK' CARPET (detail)
English; 1603
L. 5.08m (16ft 8in) W. 2.34m (7ft 8in)
ROOM 32
 Carpets from Turkey and Cairo brought to
England mainly by Venetian traders were highly
prized furnishings, most of them used as table
covers, not as 'foote carpets'. By the late 16th
century furnishings of pile knotted in the Turkish
manner and called 'Turkeywork' were being made in
England. Turkish patterns inspired several of the
larger English carpets, among them this fine piece,
with its field related to patterns of the Turkish
carpets lately known as 'Holbein' (because some of
them appear in his paintings) and its stylized Kufic
script border. The carpet was made for Sir Edward
Apsley of Sussex and his wife, Elizabeth. One end
has a knotted inscription exhorting the reader to
'FEARE GOD AND KEEPE HIS COMMANDMENTS',
helpfully adding 'MADE IN THE YEARE 1603.'
(Neg. no. 28116 No. 710-1904)

 These dolls, the earliest, largest and most
complete playthings of their type so far known to
exist, command additional interest as miniatures of
a fashionable couple of the reign of William and
Mary; a period as rich in literary and documentary
records as it is lacking in visual sources or material
remains of clothing at an important period of its
development.
 'Lord Clapham' wears the coat, waistcoat and
breeches which had replaced the doublet and hose
in the 1660s and which are, in their elements, the
suit as we know it today. The 'superfine' red cloth of
the coat is probably English, the silver brocade of
the waistcoat, sword belt and breeches probably
French-imports of about 1690. These, like the
English bobbin lace trimmed shirt, cravat, machine
knit silk stockings, buckled shoes, leather gloves,
purse and sword are precise replicas of accessories
of the period, though the hat – labelled T.
Bourdillon, King St., Covent Garden, may be a later
18th century addition, as is the maundy money in
the purse.
 'Lady Clapham's' *mantua*, a loose gown worn
over corset, chemise and petticoats was a form of
clothing introduced in the 1670s which, with
variations, was to continue in use until the end of the
18th century. The Chinese export silk of which it is
made and the *kimono*-like cut of the undress gowns
with which the dolls are additionally provided, mark
two of the many contributions made by the East
India trade to the material culture of the period. Her
accessories are as complete and precisely detailed
as those of her husband, their relationship signalized
by the gold wedding ring additionally secured by a
ribbon on the fourth finger of her left hand. Unique
fashionable survivals are her black silk mask, a 17th
century attempt at discretion and protection from
the cold, and her coiffure. This elaborate compilation
of curls, muslin, lace and ribbons supported on a
wire framework was notorious in its own time for
its height and extravagance – and its proportions
additionally confirm the date of this couple as
around 1690.
 The dolls are identical in make and shape, carved
and turned from soft wood, reinforced with wire and
padded with linen cloth. The features are painted in
gesso and the wigs are of human hair. Ensuite are
miniature chairs of caned beech and elm wood and
a foot cushion of Chinese export silk. It is
unfortunate that family tradition, apart from
providing them with a name, can shed no light on
their provenance.
Purchased by public subscription, 1974
(No. T.846 & 847)

99 PRINTED FUSTIAN FROM OLD FORD (detail)
English; 1769
L. 2.36m (7ft 9in) W. 1.91m (6ft 3in)
ROOM 124

These delightful scenes of the English gentry at their country pursuits of shooting and fishing were printed in purple from two engraved plates, solid colour being added by woodblock and by hand. These processes are rarely found so elaborately mixed and this must have been one of the most expensive textiles of the 18th century. Its manufacturer, Robert Jones, owned one of the largest printing works by the River Lea in Poplar, then well outside London. He was established there by 1759 – this piece is dated 1st January 1769 – and the works were sold in 1780.
(Neg. no. 71164 No. T.140-1934)

100 TAPESTRY CALLED 'THE ORCHARD' OR 'THE SEASONS'
Designed by William Morris (1834-96) and J.H. Dearle (1860-1932)
Woven at the Merton Abbey Tapestry Works of Morris & Company
English; 1890
2.21m x 4.72m (7ft 3in x 15ft 6in)
ROOM 118

Founded in 1881, the Merton Abbey Works had, by 1890, already become established as the most significant British tapestry manufacturer of the century. Leading contemporary artists were usually employed to produce designs for the tapestries woven by Morris & Company, but for this piece Morris designed the figures himself, the idea being taken from a cartoon made by him for a wall-painting in Jesus College Chapel, Cambridge. The background and foreground foliage of the tapestry was designed by John Henry Dearle, Morris' assistant at the works, who took over management of the Company on Morris' death in 1896.
(No. 154-1898)